Two Amish Folk Artists

Two Amish Folk Artists

The Story of Henry Lapp and Barbara Ebersol

Louise Stoltzfus

Good Books

Intercourse, PA 17534

Acknowledgments

I am deeply indebted to the many people who inspired and supported me in this project. To Merle and Phyllis Good for graciously sharing their ideas and inspirations with me. To Stephen E. Scott for many hours of careful interviews and research conducted in the Amish community in the mid-1980s. Without his work I could not have completed this book. To my parents, Jonathan and Miriam Lantz Stoltzfus, for their memories and gentle hope that these stories could be told. To the many other Ebersol and Lapp relatives who kindly and humbly shared their stories and memories with Stephen Scott and me over a period of nearly ten years. To the many Ebersol and Lapp collectors for sharing photographs of pieces from their important collections.

A note regarding the interviews done with people who wished to remain anonymous. Some relatives of Henry Lapp have been overwhelmed by the groundswell of interest in his life. Because Henry died in 1904, those who have significant memories of him are elderly, and, in traditional Amish fashion, reluctant to be identified publicly. We have tried to honor those who requested that we not give their names. Further, special thanks belong to several Amish friends who reviewed the manuscipt and offered numerous helpful suggestions.

All photography by Kenneth Pellman, except 9, left; 16; 19, left and right; 21; 22, right; 28; 29; 38; 40, left and right; 46; and 91, left by Paul Jacobs. 9, right; 10; 15, right; 23, right; and 76 by Andrew Hawkins. 20, left; 22, left; and 23, left from The Philadelphia Museum of Art collection. 20, right; 27; 47; 48; 65, left and right; 80; 84, left; and artifacts on the cover by Jonathan Charles. 25; 41, left; 90; and background cover by Richard Reinhold. 30; 75; 87; and 98 from Stephen E. Scott collection. 34; 44, top left; and 50, right by Philip Ruth. 41, top right and 100 from Heritage Historical Library collection. 44, top right from Ephrata Cloister and Pennsylvania Historical and Museum Commission. 44, bottom right from Ethel Abrahams collection. 52; 68; and 73 from Lancaster Mennonite Historical Society collection. 60 by Dawn J. Ranck. 67 and 69 from Pennsylvania State Archives. 84, right; 103; and 106 by Franklin Shores. 105, left Rare Book Department, The Free Library of Philadelphia.

Cover design by Cheryl Benner
Design by Dawn J. Ranck

TWO AMISH FOLK ARTISTS
Books, Intercourse, PA 17534
© 1995 by Good Books, Intercourse, PA 17534
International Standard Book Number: 1-56148-078-9
Library of Congress Catalog Card Number: 93-35425

Library of Congress Cataloging-in-Publication Data

Stoltzfus, Louise, 1952-

 Two Amish folk artists : the story of Henry Lapp and Barbara Ebersol /by Louise Stoltzfus.
 p. cm.
 Includes bibliographical references.
 ISBN 1-56148-078-9 (pbk.)
 1. Lapp, Henry L., 1862-1904. 2. Ebersol, Barbara, 1846-1922.
3. Amish folk artists—Pennsylvania—Lancaster County—Biography.
I. Title.
NK835.P42L357 1993
745'.092'27815—dc20
[B]

93-35425
CIP

To my beloved aunt,
Sarah Lapp Stoltzfus,
whose sense of history
and love of life inspired my own.

Table of Contents

The Family of Barbara Ebersol

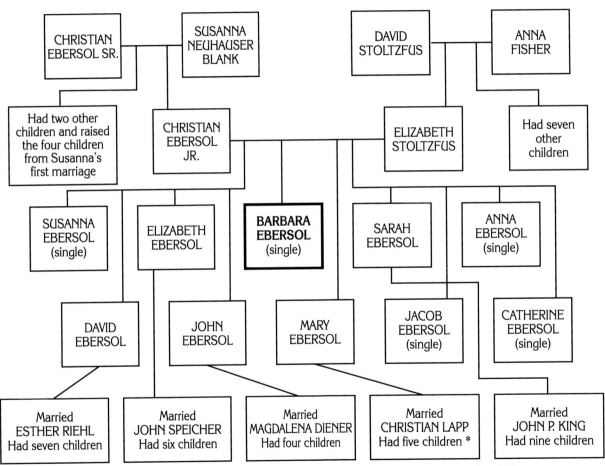

* Fannie Lapp Stoltzfus, one of the five children
of Mary Ebersol and Christian Lapp, was the author's grandmother.

The Family of Henry Lapp

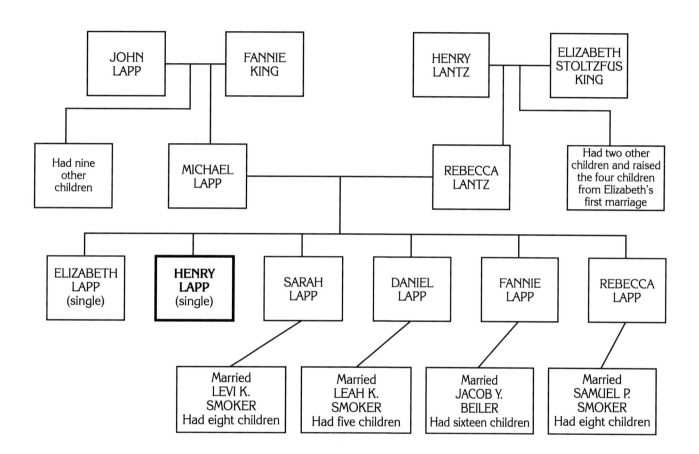

Introduction

Why a Book about Henry Lapp and Barbara Ebersol?

Many of us are increasingly intrigued by Amish life. How does an entire group of people sustain itself amid the encroachment of "the world"? Do all of its members fit the cookie-cutter sameness which we sometimes attribute to this community? If people do not quite fit the mold, how much can they vary and stay in the Amish church?

As is true in any society and in every culture, there are many people among the Amish with particular gifts of creativity and insight. This is the story of two such people—born in the mid-19th century—who have captured the interest of present-day historians, art researchers, and collectors.

Henry Lapp and Barbara Ebersol. Both were born into typical Amish families who happened to live on adjoining farms in the Mill Creek Valley of Lancaster County, Pennsylvania. Both had a handicap—Barbara was a dwarf and Henry was hearing impaired. Both were visual artists—Henry was a furniture maker and a watercolor artist; Barbara was a seamstress and a fraktur artist. Both remained single throughout their lives.

Because their creations were treasured by members of their families, as well as by others in their local community, many of the pieces they built, sewed, and painted have endured and are the reason for the interest we take in their lives today. We are as captivated by the beauty of a Henry Lapp painting or a Barbara Ebersol bookplate as we are by the fact that these exquisite pieces came from austere Amish lives. How did their artistry develop? How was it nurtured? Why is it celebrated today? Discovering those answers is the task of this book.

—Louise Stoltzfus

3

1.

The Genius and Craftsmanship of Henry Lapp

Who Was Henry Lapp?

Henry Lapp was a well-known Amish furniture maker. He was a watercolor artist. He was the owner of a hardware store and an occasional inventor. He was also a faithful member of the Amish church and lived in Lancaster County, Pennsylvania, from 1862 until 1904. A short and stocky man, no more than five and one-half feet tall, Henry Lapp was most often remembered by his family for his kindhearted spirit and his playfulness. In the words of a Lapp relative, "My mother used to say he was humorous, a joking kind of person."[1]

Most people knew him as "Henny," an ingenious artisan who compensated for a serious hearing

Henry Lapp copied numerous almanac covers. This piece is signed "Henry Lapp, 1875." Collection of The People's Place. 5⅛" x 8¾".

5

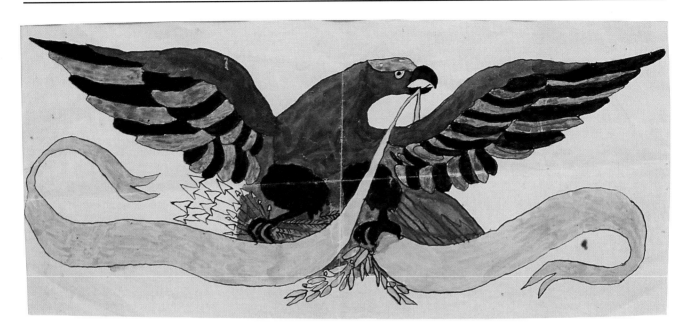

The proud American eagle stares from a colorful rendition done by Henry Lapp. Collection of The People's Place. 11¾" x 6".

impairment by communicating with people through his notebooks. Several of these notebooks have survived. One, in the collection of The Philadelphia Museum of Art, is a full color catalog with watercolor drawings of the items he built. Another, in the collection of the Heritage Center of Lancaster County, is filled with intricate diagrams of many of the items in his catalog. Another is a personal journal with dozens of pencil sketches and short questions related to Henry Lapp's everyday experiences.[2]

For the most part, the people of his community thought of him as a furniture maker and hardware store proprietor. While many of his friends and relatives enjoyed his skills as a painter, they probably never imagined he would one day be remembered for his gifts as an artist. Because of his hearing problem, he found conversation difficult. This handicap, along with the fact that he never married, meant Henry often spent his time at family and church gatherings entertaining the children by drawing and painting small sketches which he then freely gave away.

This unique combination of traits—he was an artist, he was handicapped, he never married, and he

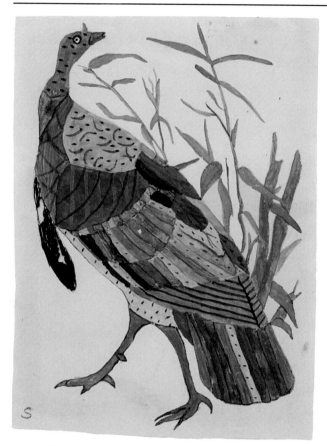

A stately pheasant, probably like those often seen darting into the cornfields on the Lapp family farm. Collection of The People's Place. 4½" x 6⅛".

Henry Lapp and his older sister, Lizzie, loved to draw and paint with watercolors. Both Henny and Lizzie had a serious hearing impairment. As children, they expressed themselves through their art. Henny continued to paint as an adult while Lizzie evidently channeled her energies into other pursuits. The Lapps produced dozens of images such as this one, featuring many different animals and plants. Collection of The People's Place. 3⅝" x 2¾".

The Charisma of Henry Lapp

While he was a kind and humble man who embodied Amish beliefs, Henry Lapp also had an inventive nature and a risk-taking spirit. His paintings provided a way for him to communicate. The furniture he built ensured a steady source of income. And the many contraptions he devised permitted him to push out the edges of his understanding. He relished life, giving his heart and soul to the

was a generous personality—made him a sort of celebrity in his own time and place. People found him interesting. Many saved his paintings, his furniture, and his stories, eventually passing them on to their children and grandchildren.

community which protected and nourished him.

One researcher suggested, "I think his art became his speech."[3] Family members support that suggestion with their memories of the get-togethers where he could be found drawing and experimenting with watercolors while the other adults visited about the weather, the crops, and the latest events in their community life. Henry usually had the children's attention as he finished yet another colorful painting of a chicken, a squirrel, or a mouse.

Indeed, his fondness for children, his careful treatment of animals, and his knowledge of the world surfaced again and again in his work. In addition to the many paintings of animals and plants common to the rural farm life Henry Lapp knew intimately, there are also paintings which show a lion, a giraffe,

The serenity and peace of Amish life are symbolized in this Amish farm at sunset. Henry Lapp's sensibilities grew out of this setting.

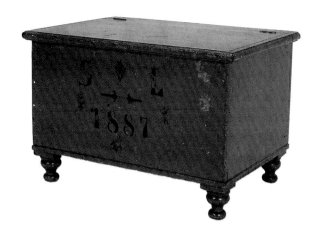

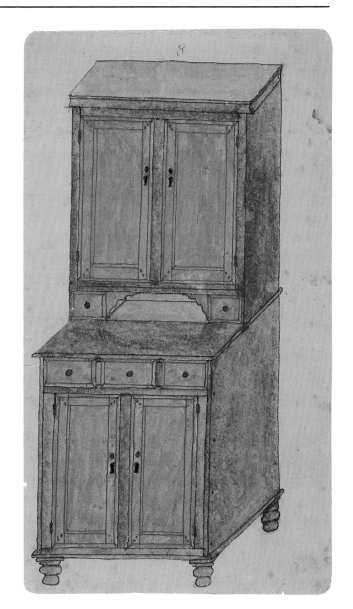

(above) In 1887 Henry Lapp built this small chest (21¼" x 14⅝" x 14") for his twelve-year-old sister, Sarah. He painted it a deep red and probably called it a "little chest." Collection of Kathryn and Daniel McCauley.

(right) As an adult, Henry Lapp became a well-known furniture maker. This is one page from his watercolor furniture catalog, discovered in the drawer of a chest some years after his death. It is said he carried this catalog with him to show potential customers what he could build. The Philadelphia Museum of Art: Titus C. Geesey Collection. 4½" x 8".

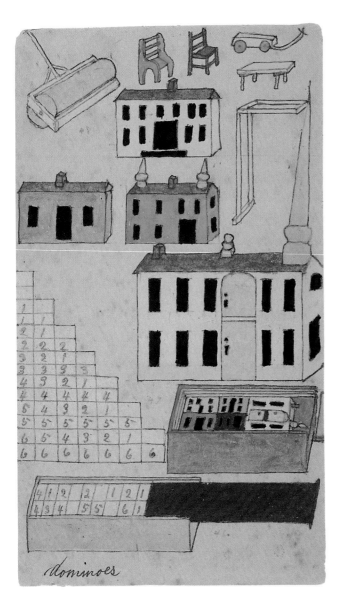

dominoes

and an elephant, as well as a collection of cartoon-like characters.

At least one of his nieces enjoyed his work enough to try her own hand at painting. Between ages ten and fourteen, Fannie L. Beiler, one of the many daughters of Henry's sister Fannie, painted a collection of subjects mimicking her Uncle Henry's style. Like Henry she drew animals and vegetables and fruits, often choosing unusual colors such as orange grapes, blue apples, and pigs with green tails for her own work.[4]

If his "art became his speech," Henry Lapp was a captivating man of striking intelligence. His furniture catalog, in particular, demonstrated a certain fearless approach to business. While his mainstay was large, sturdy household furniture, he dabbled in everything from a domino game to a toy wagon to a gaily painted wooden village. He came up with his own versions of stepladders, reading tables, threshing machines, and mouse traps. The playful energy that drove his life never appeared far from the surface and sometimes frustrated Elizabeth (also called Lizzie), the more strait-laced sister with whom he lived.[5]

Henry Lapp—Artist

From 1872 to 1879, Henry Lapp and his older sister, Lizzie, created an amazing collection of

Henry's playful energy shines from this page in his watercolor furniture catalog. From the tiny buildings of a gaily painted village to dominoes to play wagons and chairs, his imagination is evident. The Philadelphia Museum of Art: Titus C. Geesey Collection. 4½" x 8".

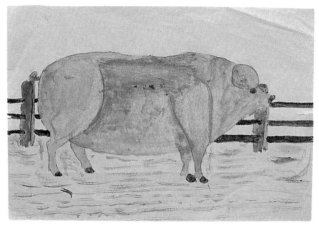

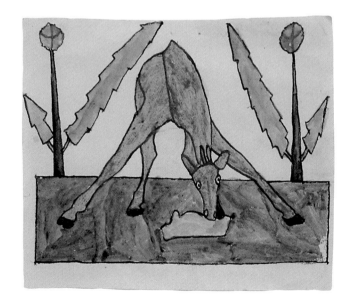

(above) This exquisite painting of a barn is signed "Henry Lapp, 1870." Done when Henry was only eleven or twelve years old, it is one of the earliest known Lapp pieces. Collection of Bob Hamilton. 6⅛" x 3⁵⁄₁₆".

(top right) One of Henry Lapp's nieces took particular interest in his paintings. In her early teens, she did a series of subjects quite similar to her Uncle Henry's. Note the green tail on this pig. This painting is signed "Fannie L. Beiler, Jan. 20, age 13." Collection of The People's Place. 6⅞" x 4⅝".

(bottom right) Remembered for his inquisitive nature and interest in his surroundings, this painting of a giraffe at a salt lick shows Henry also had significant knowledge of the wider world. Collection of The People's Place. 4⅜" x 3⅝".

Medicine label. 5½" x 3⅞".

and fables, fraktur paintings and labels on containers, and circuses, gardens, and flower beds. They painted distelfinks, farm animals, scenes from storybooks, circus-like characters, labels for medicines such as Jayne's Sanitive Pills, and many different fruits, vegetables, and flowers. Given the variety of their subjects and the delightful colors they used, Henry and Elizabeth Lapp thoroughly enjoyed

watercolor paintings. Many of the paintings from this time were collected in a scrapbook and saved by Lizzie Lapp. While some researchers and collectors originally believed Henny was the artist and Lizzie the recipient, variations in the style, as well as signatures on the paintings themselves, suggest she also painted some of the pieces.[6]

Historians and collectors alike have come to believe they inspired each other. Henny and Lizzie, who also had a hearing loss quite similar to Henny's, evidently spent many hours during their childhoods painting whimsical renditions of the world around them. Both these children of Michael K. and Rebecca Lantz Lapp demonstrated a genius of expression unmatched in the close-knit 19th century community where they were nurtured.

The sources of their inspiration included farm life

A monkey trainer. 3¾" x 4½".

The paintings on pages 12-14 demonstrate the wide array of subjects which interested Henny and Lizzie Lapp. From strawberries to distelfinks and monkey trainers to medicine labels, they seem to have enjoyed painting a great deal. All are in the collection of The People's Place. Strawberries, 7½" x 5½". Distelfink, 10¼" x 7⅞".

painting. The Lapp paintings demonstrate a profound love of life and a time of freedom and discovery.[7]

In later life Henry, unlike Elizabeth, found unique ways to make painting work for him. As an adult he became a master carpenter and a respected furniture maker. In 1956, his furniture catalog notebook was discovered in a bureau sold to an antiques collector by a descendant of the Lapp family. Inside this plain

(above) This painting of a horse is signed "Henry Lapp, 1876." Collection of The People's Place. 4⅜" x 3½".

(right) This plate from Henry's furniture catalog shows his fascination with gadgets. Collection of The Philadelphia Museum of Art: Titus C. Geesey Collection. 4½" x 8".

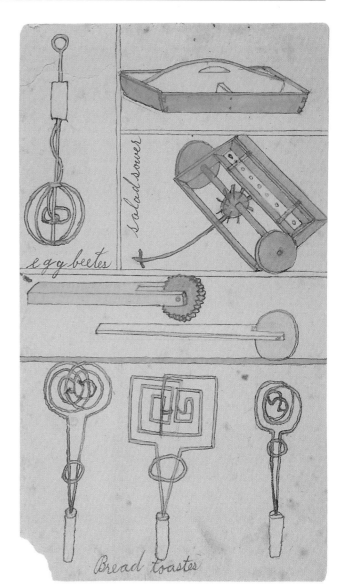

booklet of coarse paper appeared a collection of watercolor drawings depicting furniture, farm implements, household items, and even games and toys.[8] According to oral family history, Henry carried this furniture catalog with him and used it to show potential customers what he was capable of producing.[9]

For reasons which are unclear, Lizzie was not known to have painted as an adult. Family stories maintain she was unusual in her own way. She

worked as a seamstress, creating exquisite Amish dolls, but she did not paint in the presence of friends and relatives.[10] Henry, on the other hand, probably painted hundreds of charming watercolors in his lifetime. While only a small percentage of his work survives, no other known 19th century Amish folk artist, including his sister Lizzie, was as prolific or matched his talent.

Henry Lapp—Furniture Maker and Inventor

In the spring of 1893, 30-year-old Henry Lapp purchased a tract of land along the Old Road, the main route from Lancaster to Philadelphia, and immediately set to work building a home for himself. With the help of his neighbors, he built an L-shaped house, a half-stone barn, and a long, narrow shop, painted bright red and lined with windows.[11] The house, which stood quite close to the road, became home to Henry and his sister, Lizzie. Sometime during the years he lived there, Henry Lapp scratched his name on one of the inside beams of the barn which stood on the north side of the house. The shop, built west of the house and also quite close to the road, became the center of his thriving furniture, paint, and hardware dealership.[12]

Henry Lapp also traveled frequently. Both the Ronks and Bird-in-Hand railroad stations were within easy walking or driving distance of the Lapp home. According to his personal journal, he commonly used the trolley and railroad in his travels. (An account published in the *Papers of the Lancaster County Historical Society* in 1902 proclaimed, "The

(above) Henry Lapp built this desk for Samuel L. Fisher (circa 1890). It has eight drawers on the inside. Each drawer has a number on the back, handwritten in pencil by Henry Lapp. Collection of The People's Place. 40" x 22¼" x 45½".

(facing page) A page from Henry's tiny diagram notebook (2¾" x 4¼") shows the various features, dimensions, and cost of a Lapp desk. Collections of The Heritage Center of Lancaster County.

Philadelphia and Lancaster turnpike today exists only in name." After acknowledging that the roadbed once carried thousands of great Conestoga teams and wagons, the report further declared, "The turnpike was unable to compete with the iron road

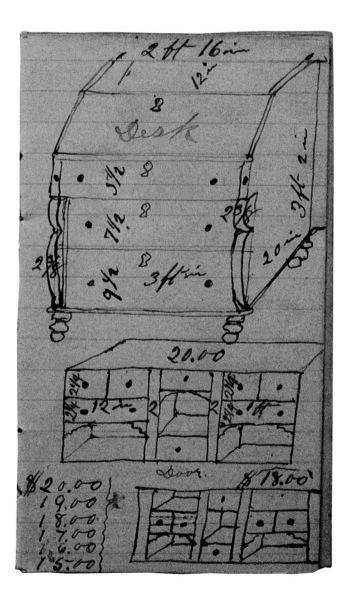

and the iron horse."[13]) While Henry Lapp may occasionally have taken a horse and wagon to Philadelphia to deliver and pick up supplies, he, like many people of his time, probably preferred rail travel.

Some sentences in Henry's personal journal appear to have been coded writing, but many more were straightforward questions such as, "When does the next train leave for Philadelphia?" The journal also contains lists of medicines, tools, food, paint colors, train stations, trolley stations, important historical events, and interesting sites in Philadelphia. Names and addresses of people with whom he did business fill the pages of this pocket-sized treasure. Further, the book includes numerous tiny labeled sketches of many different items—an extension drop-leaf table, different sizes of nails, the human body with its different parts, a parcheesi game, and even a quilt.

In one small section, Henry started at the bottom of the page and, writing backwards toward the top, poured out his story of asking a young woman for a date, only to have her reject his offer.[14]

Lapp's furniture catalog and his diagram notebook, also served him well. After showing potential customers what was available, he would take orders. Many Lancaster County Amish people of the time bought their furniture at Henry Lapp's shop. Folklore further maintains that Lapp did a thriving business in the surrounding cities of Lancaster, Reading, and Philadelphia.[15]

As his business grew, he purchased more land, continued building exquisite furniture, and even did

some farming on the side. According to Henry's business envelopes, he was a "manufacturer and dealer in all kinds of furniture, also paints, oils, varnishes, brushes, glass, nails, and many notions, etc."[16]

In addition to running his furniture shop and hardware store, Henry Lapp also found time to experiment. On November 25, 1898, he filed an application with the United States Patent Office for a shutter bolt which he designed. With the help of his attorney, William R. Gerhart, Lapp explained his invention, "I, Henry L. Lapp, a citizen of the United States, residing at Bird in Hand, county of Lancaster, State of Pennsylvania, have invented certain Improvements in Shutter-Bolts."

In his application Lapp defined the purposes of his invention: "First, with the same bolt to lock the shutters in a closed position or to secure them in any

The shutter bolt invented by Henry Lapp. On February 7, 1899, he received a patent to produce these bolts from the United States Patent Office. Diagram from a bill of sale in the collection of Bob Hamilton.

bowed position desired, and, second, to secure the shutters firmly in a fully-open position." He further pointed out that other shutter bolts in use at the time created difficulty "in disconnecting the hook from the eye, and in so doing the hook is very liable to be broken off. My bolt overcomes these difficulties."[17]

Since shutters were commonly used on the windows of homes in the late 1800s, Henry Lapp probably found significant demand for his invention. For an unknown reason, Henry bequeathed the shutter bolt patent to his step-cousin, Noah Beiler. Beiler made no mention of the patent in his own will, dated September 4, 1945.

Several other facts about Henry Lapp's extraordinary life come from a study of the 1900- 1904 copies of *The Sugarcreek Budget* conducted by David Luthy, an Amish historian. In his 1988 research, Luthy discovered the Lancaster correspondent to this weekly Amish newspaper occasionally reported on Henry Lapp's activities. On August 2, 1900, Henry Lapp was "very busy making new furniture," having just finished a fine bureau for Fannie Miller. Three weeks later Henry decided to take a ten-day vacation to Niagara Falls, saying it was too warm to work in his shop.

In spite of his Amish upbringing and his hearing impairment, Henry Lapp was a worldly-wise man. He was also deeply dedicated to his Amish community and his quiet farm home. In April 1901, Lapp reported intending to "plant about a quarter of an acre in strawberries this spring." The March 13, 1902, issue found Henry so busy that he hired an assistant: "Noah F. Zook is working for Henry L. Lapp in his furniture factory."[18]

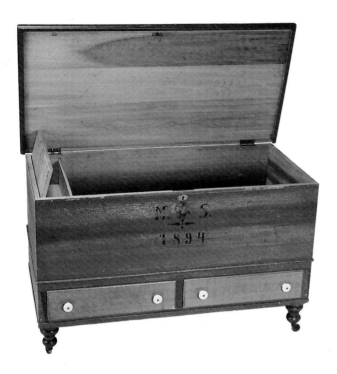

A blanket or dower chest built by Henry Lapp in 1894. Collection of The People's Place. 49" x 23¾" x 28¾".

The Sources of Henry Lapp's Inspiration

Henry Lapp built furniture of the Pennsylvania German tradition. An Amishman of south German ancestry, he was a fifth generation Pennsylvania native on both his father's and his mother's sides.[19] The particular forms and techniques of the German furniture makers of southeastern Pennsylvania are deeply imprinted in his creations.

The Lapp wall cupboards (see page 20), for example, were conceived in the form of the tall, two-piece Pennsylvania German kitchen cupboards. One fine piece made in Mount Joy (about 20 miles from Lapp's home) in the early 1800s has been preserved by The Philadelphia Museum of Art. The similarities between the Mount Joy cupboard and a wall cupboard, signed "Henry Lapp, 1902" and owned by The People's Place, help connect his inspirations to this particular Germanic tradition.

Further, his three- and four-drawer slant-top desks (see page 22) hearken back to a desk built by Jacob Bachman in Northampton County, Pennsylvania, in the late 1700s. Lapp's harvest

Henry Lapp made numerous small keepsake boxes in this style. This one is unusual because of the painting of Niagara Falls on the lid. Collection of Kathryn and Daniel McCauley. 8½" x 7¼" x 3¼".

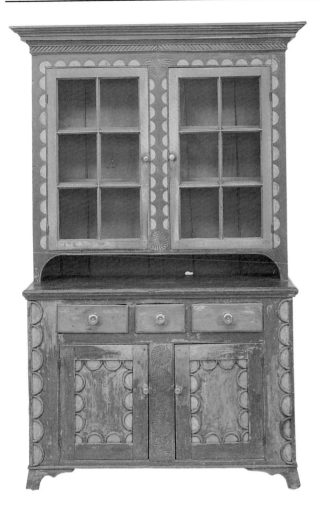

This cupboard was built near Mount Joy, Pennsylvania (about 20 miles from Henry Lapp's home), sometime between 1800-1830. The Philadelphia Museum of Art: Titus C. Geesey Collection. 60" x 20½" x 85¼."

This cupboard was built by Henry Lapp, circa 1890. It is one of several known wall cupboards with poplar interiors painted a robin's egg blue. Note the similarities and differences between the Mount Joy cupboard and this piece. Collection of The People's Place. 51" x 21" x 84".

tables (see below) evoke the common Pennsylvania German tables with removable tops and different-sized drawers, often painted red, and built in the early 1800s. And his dough tables (see page 23) are quite faithful renditions of the popular dough tables constructed between 1750-1800 in southeastern Pennsylvania.

While Pennsylvania craftsmen, including Amish and Mennonites, created furniture for their own homes and for their neighbors and friends from the time they settled in the New World, most scholars date the zenith of the Germanic tradition in Pennsylvania somewhere between 1760-1830. By the mid-19th century many Pennsylvania German

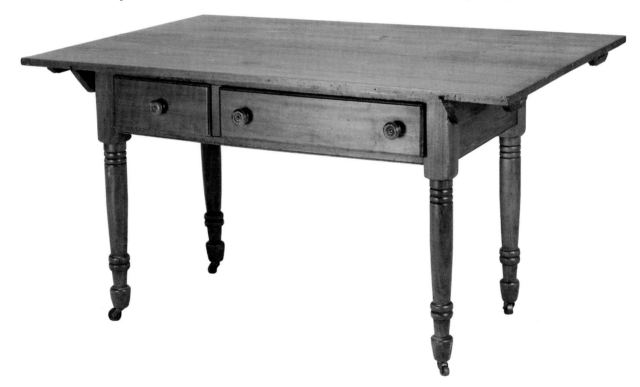

Lapp's harvest tables include many of the unique features of Pennsylvania German farm kitchen tables—removable tops with pegs to secure them to the base, two drawers of different sizes, and leaves for each end. Collection of The People's Place. Top: 57" x 38". Base 42" x 22½" x 28¾".

The three-drawer desk (right) built by Henry Lapp (collection of The People's Place) follows quite closely the forms of the Jacob Bachman desk (left) built in the late 1700s (collection of The Philadelphia Museum of Art: Given by Mrs. Walter J. Kohler).

people had become quite well-to-do. More and more frequently their (those who were not Amish) tastes in home furnishings reflected the larger society. They began buying Chippendale, Windsor, Federal, Empire, and, eventually, even Rococo Revival furniture. Popularly called the "French Antique" style, Rococo furniture found an enthusiastic audience in the United States as early as the 1840s and continued into the first decades of the 1900s.

However, while their Germanic neighbors gradually discarded "old-fashioned" furniture, the Amish never stopped building and buying the solid, tried-and-true forms of Pennsylvania German furniture. They preferred furniture which looked like

it should be used. Furthermore, they shied away from the elaborate carvings and ornate decorations of much late 19th century furniture.

Therefore, Amish cabinetmakers tended not to employ decorative elements in their furniture, and Amish-made furniture slowly developed its own identity. While the forms and designs of Pennsylvania German furniture are clearly repeated in Amish furniture, the more decorative elements of this same furniture are often absent from pieces built by Amish men.

For example, Henry Lapp's chests were similar in design and workmanship to the popular Pennsylvania German chests which featured elaborate carvings, paintings, and fraktur inscriptions. However, Lapp's chests were universally plain by comparison. With the exception of the date, the initials of the owner, small decal decorations, and occasional grain painting, Lapp did not decorate his chests. Rather, he usually finished the well-crafted poplar pieces by painting them a solid color, most often red. (See page 27 for an example.)

Henry Lapp also did very little decorative carving. For example, he usually built his wall cupboards with

The dough table (right) from Lapp's furniture catalog (The Philadelphia Museum of Art: Titus C. Geesey Collection) is also quite similar to this Pennsylvania German dough table (left). The Philadelphia Museum of Art: Gift of J. Stogdell Stokes.

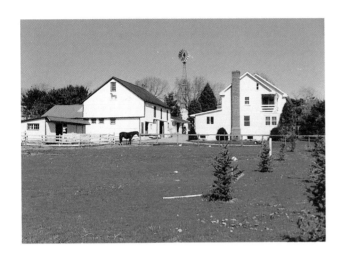

Well known for his skills as a carpenter, Henry Lapp purchased a small acreage from a friend in 1893 and, with the help of his neighbors, built a house, barn, and furniture shop. The furniture shop was dismantled in the 1950s. This is a view of the house and barn that Henry built as they appeared in 1994.

walnut and poplar wood. The top units of his cupboards often had glass doors. Lapp frequently painted the insides of the cupboards and the shelves (usually built of poplar) a robin's egg blue, demonstrating the strong inclination toward simple beauty in Amish life. The exteriors of his cupboards, almost always of walnut, were given an elegant finish with a solid, plain look.

So while the Lapp wall cupboards are similar in design and form to the Pennsylvania German kitchen cupboards, such as the early 1800s Mount Joy cupboard, (see page 20), they appear much

different. The Mount Joy cupboard, for example, features elaborately carved moldings, carved pinwheels on the center stiles, and carved diagonal reeding under the cornice. It was brightly painted and has a much splashier and more decorative look than the plain walnut of the Henry Lapp wall cupboards. For design and form, then, Henry Lapp clearly received inspiration from the Pennsylvania German furniture of his area. However, he chose to forego elaborate decorations because he built much of his furniture for the people of his Amish community.

In an 1890 listing of all the heads of households living in Lancaster County, Henry L. Lapp, Groff's Store, was identified as a carpenter. His mother was given the unusual distinction: "Rebecca Lapp, wid. farmer, Groff's Store."[20] Evidently, in 1890 at age twenty-eight Henry still lived on the Lapp family farm. It appears his mother and other siblings did the farming while he built furniture.

A number of Amish furniture pieces from the late 1880s have been attributed to Henry Lapp. For example, a painted poplar chest complete with secret drawer stayed in the Rebecca Lapp Smoker family for nearly one hundred years. The chest, which Henry made for his sister, Rebecca, was initialed "R L 1887" (see page 27 for photo). Other pieces from that time, along with the 1890 directory's clear statement that he was not a farmer, lend support to the belief that Henry had set up a woodworking shop.

It was after Henry Lapp bought his own land and built a new furniture shop near the Old Philadelphia Pike in 1893 that he began calling himself a cabinetmaker. In the 1896 heads of households

listing, Lapp's name appeared with the cabinetmakers rather than the carpenters: "Henry L. Lapp, cabinetmaker, Bird-in-Hand."[21]

According to Joseph Butler in his *Field Guide to American Antique Furniture*, cabinetmakers generally served apprenticeships, during which time they learned to construct and, especially, to carve fine furniture. Joiners and turners tended to be less style-conscious, less trained, and less sophisticated.[22] Carpenters, by contrast, were people who built houses, barns, and other structures.

Henry Lapp may have served an apprenticeship where he trained in the arts of joinery, learning

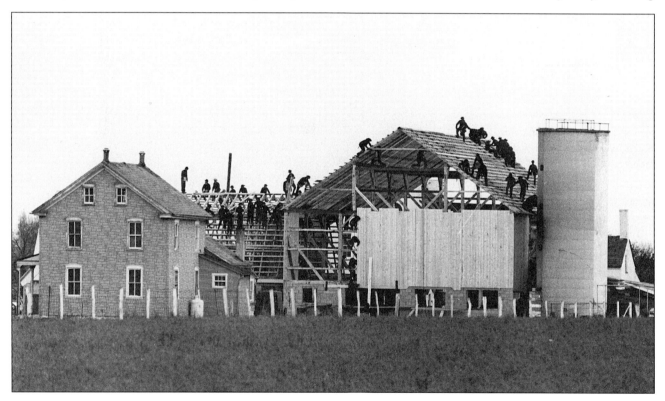

Amish men have traditionally had significant carpentry, as well as farming, skills. Community togetherness and carpentry merge in this most intriguing of Amish practices—a barn raising.

25

techniques such as splined dovetails and pegged mortise and tenon joints. As demonstrated in Lapp's furniture catalog, he also developed significant skills with a lathe, using lathe-turned feet and legs on most of his furniture. Though he did not do a great deal of carving, the superior quality of his workmanship certainly supports Henry Lapp's decision to change the description of his work from carpenter to cabinetmaker sometime in the early 1890s.

Only one other Amish name appeared in the 1896 cabinetmakers' list—Jacob Flaud, who would have been in his late 50s or early 60s at the time. This same Jacob Flaud with his wife Elizabeth Weaver Flaud raised a family in the Eby's Post Office area of Lancaster County during the mid-1800s. It is possible that Jacob Flaud taught Henry Lapp his trade.

While no Lancaster County Amish furniture has been attributed to the older Jacob Flaud, some pieces have been traced to his mid 20th century carpenter grandsons, Jacob U. Flaud and David Flaud. Jacob U. Flaud and David Flaud spent most of their time building houses and other structures, but they also built furniture. Jacob and David married sisters, two of Henry Lapp's nieces, Sarah and Fannie Beiler. In 1932 Jacob U. Flaud purchased the small farmstead which Henry had built. It is said that Jacob U. Flaud occasionally built furniture in Henry's shop, using Henry's tools and equipment.[23]

Furniture for His Community

Much of the furniture Henry Lapp crafted stayed in his own community. He built desks, wall cupboards, chests, wash benches (dry sinks), and beds because Amish families bought such pieces for themselves and for their children. A young Amish man often received a desk from his parents before he married. A young woman, on the other hand, usually received a chest which she then worked to fill with embroidered linens and other keepsakes in preparation for her wedding. From the mid-1880s until 1904, many Lancaster County Amish families placed orders for furniture with Henry Lapp. Stories of grandparents and great-grandparents buying furniture from his shop still float through the Amish community.

An inventory taken at the time of Lapp's death in 1904 reveals a customer list. Of the twenty-five people who owed him money, twenty-two had Amish surnames. For example, Barbara Fisher owed him $66.65, Annie M. Lapp owed him $27.25, and Jonathan Stoltzfus owed him $2.50.[24]

Another of Henry Lapp's ever-present small notebooks discloses much more about his furniture business (see page 17 for photo of page from this notebook). Owned by the Heritage Center of Lancaster County, the notebook is a vertical, pocket-sized booklet (2¾" x 4¼").[25] Inside are pages of tiny pencil sketches, showing his furniture and various other gadgets—toasters, flour shovels, and even a checkerboard. Each diagram includes detailed dimensions. Most are also numbered and priced.

The second diagram in the booklet is a desk similar to the desk Henry built for Samuel L. Fisher (see page 16). The dimensions are all clearly marked.

Beneath the desk drawing are two possible versions of pigeonholes, along with a gradation of prices— $20.00, 19.00, 18.00, 17.00, 16.00, 15.00. Obviously, the purchaser could choose certain features, and Lapp would adjust the cost accordingly.

Numbers 46 and 47 in the diagram notebook are labeled high bedsteads and demonstrate that Henry Lapp occasionally used his carving skills. They are priced $6.75 and $7.00.

According to this particular Lapp notebook, he

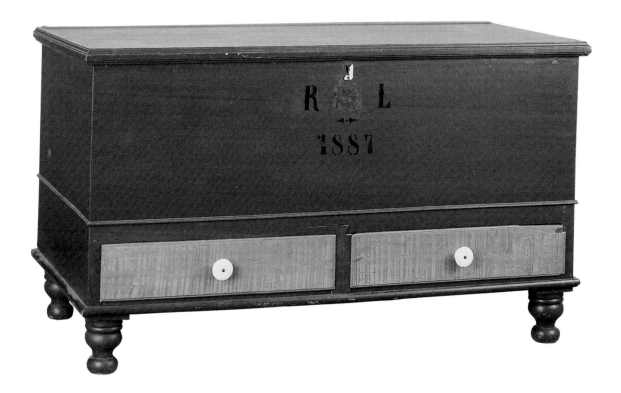

In 1887 Henry Lapp built this poplar chest for his sister, Rebecca. He painted it a deep red and included grain painting on the drawer fronts. The chest, complete with a secret compartment accessible from the back, stayed in the Rebecca Lapp Smoker family for nearly 100 years. Collection of The People's Place. 50" x 24" x 28½".

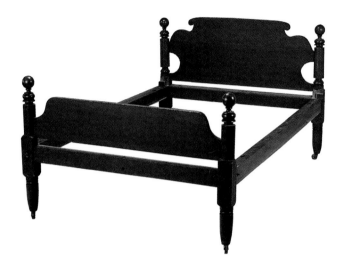

A rope bed attributed to Henry Lapp. Collection of The People's Place. 77½" x 53½" x 40¾".

had two versions of the ever-popular chest of drawers. Lapp called his chests "bureaus" and sold them for either $15.00 or $16.00.

In his day, he had to compete with catalog companies such as Montgomery Ward. An 1897 Montgomery Ward Furniture Catalog reveals that, like Henry Lapp, they also offered desks for a gradation of prices, $19.50, 14.50, 12.65. The catalog shows a vast collection of bedsteads, ranging from a plain iron one for $3.25 to an elaborate brass one for $49.00. The Montgomery Ward chests of drawers, which they called chiffoniers, sold for an average price of $15.00.[26]

Henry Lapp's prices for his custom-built furniture were very competitive for his time. Many Amish

people probably preferred to buy furniture from Henry Lapp because he made it to their specifications and because his prices were well within most of their budgets.

Remembered for his good-hearted nature and his desire to help those less fortunate than himself, Henry Lapp made a good living but never strived for wealth. He took vacations when he felt like getting away. He relaxed with his nieces and nephews. And he also occasionally spent a morning working his land or planting strawberries. A man of simple means and few pretentions, Lapp, nevertheless, also took great pride in his work.

The Lapp furniture shop itself demonstrated his genius. A large windmill, designed to work efficiently with wind velocity as low as five miles per hour, was secured to the roof to provide power to run his saws and lathes. One family member remembers stories of Henry jumping up from the dinner table when the wind picked up, sometimes leaving a plate of food, and heading to the shop to finish a particular project.

Inside his shop, the sturdy and functional workbench stood directly in front of a window. To the left of the workbench, a specially designed cabinet kept a large assortment of nails from becoming mixed. And to the right of his workbench, another cabinet held his account books and other related paperwork. A rope-powered elevator carried lumber and supplies between the two floors of the building.[27]

Henry Lapp obviously enjoyed the opportunities his success offered him. His frequent travels to the nearby cities of Lancaster, Reading, and Philadelphia supplied him with another market for his work.

Furniture for Those Outside His Community

If, in fact, the height of popularity for Pennsylvania German furniture occurred between 1760 and 1830, the furniture crafted by Henry Lapp should have held little appeal for the modern and increasingly mobile people of the cities near his Bird-in-Hand home in the late 1890s and early 1900s. Lapp family folklore, however, has handed down the firm belief that his customers included people who were not Amish.

Remembered as a skilled and diligent cabinetmaker, Henry Lapp went to the nearby cities both to support and supply his trade.[28]

As he traveled, he took with him his trusted personal journal, his watercolor furniture catalog, and his diagram booklet. The catalog and diagram booklet showed what he could make. The journal included a list of names and addresses of people with whom he did business.[29] Lapp's success and appeal among buyers from beyond the Amish community may be related to the fact that he made an older style

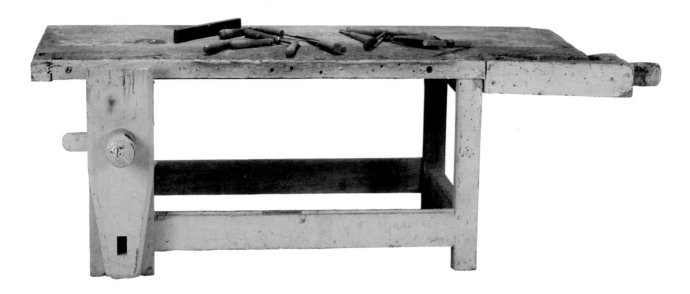

The workbench where Henry Lapp spent hours constructing furniture. Saved when Henry's shop was dismantled in the early 1950s, it is now the centerpiece of the Henry Lapp Museum at the Old Road Furniture Company in Intercourse, Pennsylvania. Collection of The People's Place. Top: 96" x 32" x 3". Base: 60" x 32" x 31¼".

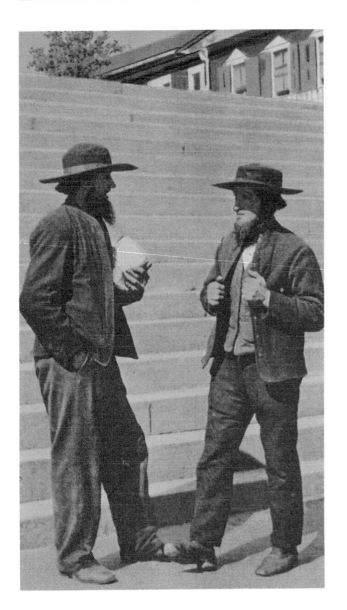

of furniture at a time when people were interested in antiques and colonial furniture.

During the 1870s and 1880s, it had become fashionable to collect antiques. In fact, the 1876 Philadelphia Centennial Exposition, which thirteen-year-old Henry Lapp may have attended with his family (see page 76), focused on the past and kindled a zeal for collecting old pieces of American furniture, including the sturdy 18th century Pennsylvania German chests, cupboards, and tables. As may be expected, this fascination with the past also inspired the creation of antique reproduction pieces.[30] Henry Lapp's city customers may have been charmed by the seminal quality of his work. While he created pieces out of and for his tradition, he was also able to sell work to people who were not Amish because they were interested in the past and in collecting antiques.

One of the finest craftspersons of his era, Henry Lapp was also one of the premiere Amish furniture makers of all time. Nearly one hundred years since their creation, some of his original and finely crafted pieces still stand in Lancaster County Amish homes. In an interesting twist of fate, the Lapp legacy also lives on in the work of contemporary Amish cabinetmakers. Some of them now find themselves building reproductions of Henry Lapp furniture.[31]

Two Amish men converse near the courthouse steps in downtown Lancaster, Pennsylvania, in the early 1900s. Henry Lapp traveled frequently to the nearby cities of Lancaster, Reading, and Philadelphia.

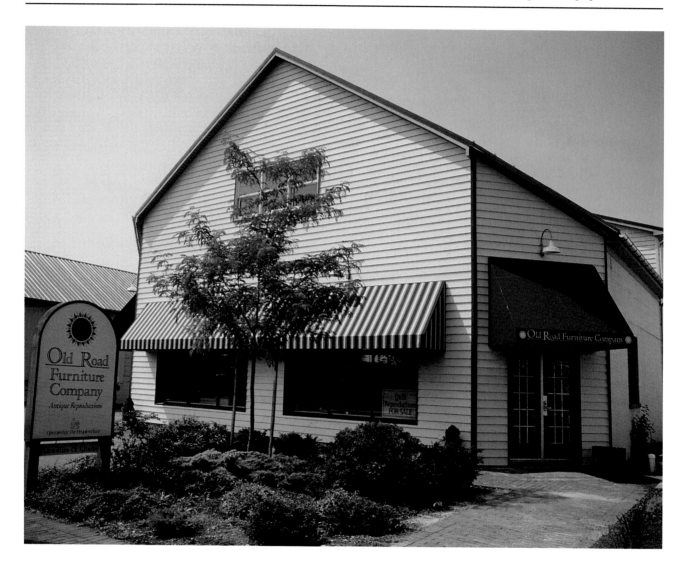

The Old Road Furniture Company, Intercourse, Pennsylvania. Located within several miles of both Henry Lapp's birthplace and his adult home, this furniture company produces reproductions of Henry Lapp furniture.

2.

The Artistry and Charm of Barbara Ebersol

Barbara Ebersol—Artist and Seamstress

Barbara ("Bevli") Ebersol, a Lancaster County Amish woman remembered for her talents with watercolor and thread, spent much of her adult life, from the late 1800s until 1922, traveling from Amish farm to farm sewing men's Sunday suits and "marking books." A term still used among the Amish, marking books meant she decorated and inscribed German Bibles, hymnbooks, or other treasured family keepsakes with a form of calligraphy and painted decoration called fraktur. Ebersol, who inherited the traits of dwarfism, was the fifth of ten children of Christian and Elizabeth Ebersol, a well-to-do 19th century Amish farming family. Like Henry Lapp, Barbara Ebersol never married.

When Bevli (pronounced Bev' li) was asked to

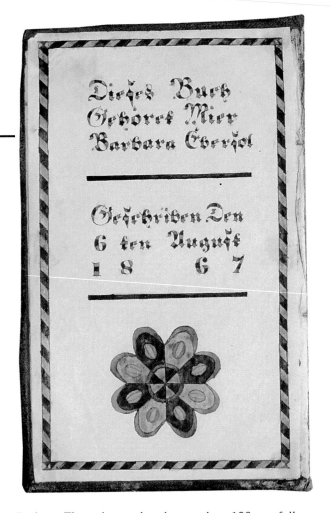

Barbara Ebersol completed more than 100 carefully painted fraktur bookplates in her lifetime. On August 6, 1867 at the age of 21, she finished this piece on the inside frontcover of her own treasured Ausbund. *Collection of The People's Place. 3⅝" x 6".*

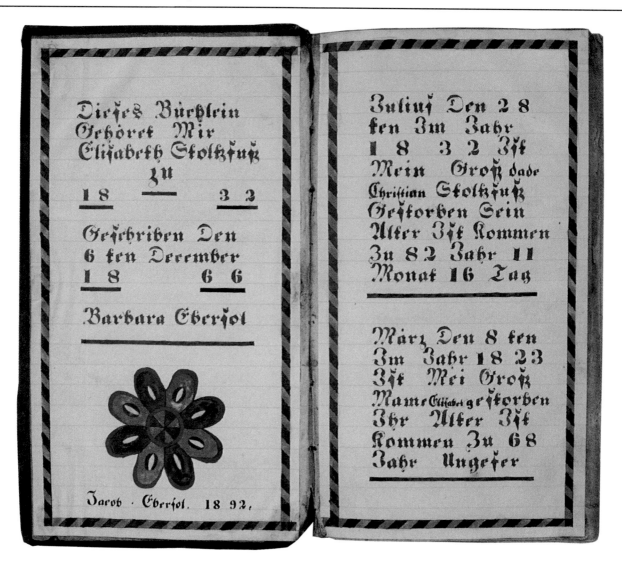

This magnificent double bookplate was completed for Barbara's mother, Elizabeth, in 1866. The persons referred to in the death record on the right are Barbara's great-grandparents. Collection of Bob Hamilton. 8¾" x 7⅝".

Dieses Buch
Gehöret Mir
David Blank
Empfangen von
Meinem Groß
Dade Jacob Blank
Im Jahr 18 87

Barbara Ebersol

In 1887 Barbara Ebersol marked this book entitled Weinban in Garten *for a David Blank. A German instruction manual for grape growers, it was published in Lancaster, Pennsylvania in 1828. Collection of The Mennonite Historians of Eastern Pennsylvania, Harleysville. 4⅛" x 6¾".*

mark a book, the book's owner usually requested that his or her name and a date be inscribed inside the front cover. Any of a variety of dates—the owner's birth date, the date when the painting was completed, or the date the book was given as a gift—appeared on these pieces. While people frequently asked her to mark their Bibles and hymnbooks, she also once inscribed the inside front cover of an 1828 publication which gave detailed instructions for growing grapes and included a section on making wines.[1]

Whether or not Barbara charged people for marking their books has not been established. No doubt, families provided her with room and board, as well as paid her for the sewing which she did. Most Amish clothing at the time was handmade, usually by the women of the family. Special items such as men's Sunday suits, women's bonnets, and rugs and bedding were often made by seamstresses. Barbara Ebersol was such a seamstress, and she was probably paid for that work.

People may also have paid her for the paintings, but it is doubtful she received significant income from her fraktur work. Rather, marking books may have been a source of relaxation for her after a long, exhausting day either sewing by hand or, after its invention, pumping a treadle-powered sewing machine.

In addition to the treasured fraktur pieces, members of the Lancaster Amish community saved various other craft items created by Barbara Ebersol. Well liked by her nieces and nephews and neighbors and friends, she often presented gifts to those close to her. After describing her Christmas of 1891,

Betsy Speicher told her cousin Sarah, "I got a little cup and saucer and a handkerchief from Aunt Barbara."[2] According to family history, the keepsakes from Aunt Barbara included items such as cross-stitched embroidery on handkerchiefs,

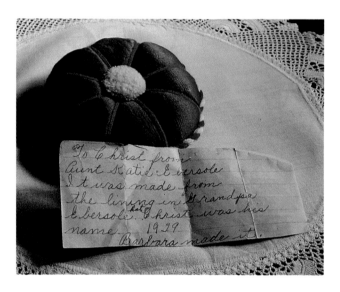

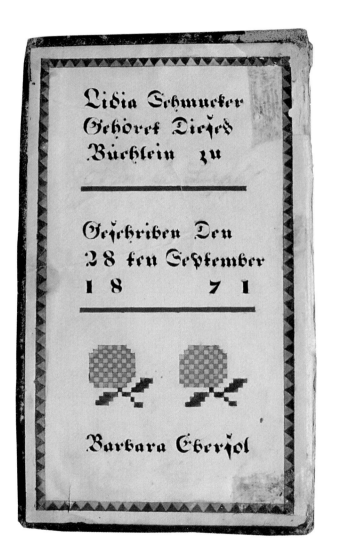

(above) Barbara Ebersol made this exquisite pin cushion for her sister, Catherine (Katie). In 1929 Katie gave it to her great-nephew, Christ Speicher. Collection of Muddy Creek Farm Library. 4¾" in diameter.

(right) Barbara marked this Ausbund, an Amish hymnbook dating from the 16th century and still used during Amish church services, for Lidia Schmucker in 1871. During this stage of her life (ages 13 to 25), Barbara signed a number of her bookplates with her full name. Collection of The People's Place. 3⅝" x 6".

knitted linen washcloths, star-shaped pincushions, and decorated cigar boxes.[3]

Bevli also taught fraktur to at least one person. Her niece, Fannie Lapp Stoltzfus, one of the daughters of Barbara's sister Mary, learned her techniques and copied her styles from days and weeks of watching Bevli work when she was staying at their home.[4]

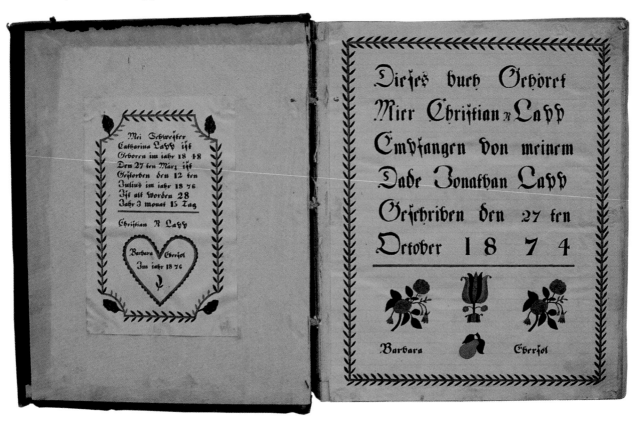

Barbara Ebersol painted this unusual double bookplate for her brother-in-law, Christian N. Lapp. The left plate is a death record for Christian's sister, Catherine, who died at age 28 in 1876, the year Barbara painted the left plate. The right plate was painted in 1874, the year of Christian's marriage to Barbara's sister, Mary. Collection of Sam Stoltzfus. Left plate, 4¾" x 7". Right plate, 8¾" x 11".

(left) A bookplate completed by Barbara Ebersol's niece, Fannie Lapp Stoltzfus, 30 years after Barbara's death. Privately held. 4¼" x 7".

(right) A Barbara Ebersol bookplate which demonstrates the sources of Fannie Lapp Stoltzfus's designs and lettering. Collection of The People's Place. 3½" x 6".

While Fannie's work was much more uneven and much less defined than Barbara's work, her choice of brilliant colors, spiderweb roses, and leafy borders nevertheless reflected her Aunt Barbara's work. When Fannie married Amos U. Stoltzfus in 1911, she had Barbara begin a family record on the inside of their large German family Bible.[5]

Barbara Ebersol—Traveler

While Bevli apparently still lived with her parents at age 25 in 1870, changes on the Ebersol farm created new living arrangements around 1876. That year her parents, Christian and Elizabeth, built a two-and-a-half-story retirement house within a short distance of their farm's main house. Their bachelor son, Jacob, took over the day-to-day farm operations. He, with his single sisters—Susan, Barbara, Sarah, Anna, and Katie—continued to live in the original house. In 1878 after asking her sisters for permission, Sarah married John King and moved to a farm along the Pequea Creek in Strasburg Township.[6] Eleven years later on May 16, 1889, Jacob Ebersol bought his father's Mill Creek farm for $15,172.50.[7] Barbara's father, Christian Ebersol Jr., died at age 75 in 1890 and her mother, Elizabeth, died about a year and a half later on January 25, 1892.

Sometime, then, in the last years of the 19th century, Barbara began her well-remembered traveling from farm to farm. On October 4, 1897 Barbara's niece, Betsy Speicher, wrote a letter to her cousin, Sarah Lapp. The daughters of two of Barbara's sisters, Betsy and Sarah were best friends. In this letter Betsy told Sarah "last Sun Aunt Barbara

went along home from meeting she staid till Tues afternoon then we got her to help to sew carpet rags."[8]

At some places Bevli visited for weeks at a time, creating family legends which maintained she actually lived in those homes. Two chairs kept in her sister Mary's home on Irishtown Road were called the "Bevli chairs." One, a rocking chair, still stood near a front corner window into the mid 20th century, often prompting the memory of Barbara's

niece, Fannie Lapp Stoltzfus. The other, a straight chair, displayed well-worn marks on its front rung where, it was said, Barbara rested her feet because they did not reach the floor. Barbara Ebersol spent many weeks of her life with her sister Mary and family.[9]

Each spring and fall she spent several days at the home of one of her nephews, the Jonas Ebersol family. While there, she helped with the sewing and occasionally made pincushions or decorated cigar boxes. Each morning Bevli cut in half two of the hand-rolled cigars which she carried with her everywhere she went. She smoked half of one before breakfast, another half around nine in the morning, another immediately after the noon meal, and the last half after supper in the evening. Because Jonas's wife, Lydia, disapproved of her smoking in the house, Bevli went outside to smoke. When it was too cold, she sat by the stove used for heating and blew the smoke into its door.[10]

In later life Barbara's legs became weak and she walked with crutches. When she died, her youngest sister, Katie, saved the crutches, taking them with her when she left the Ebersol home to move in with one of her nieces in the Millwood area. The crutches measure thirty inches, making it possible to estimate Barbara's height at about three feet, six inches.[11]

(left) A fine seamstress, who spent much of her time sewing men's Sunday suits, Barbara also occasionally did embroidery work such as this needlework on punchboard. Collection of Kathryn and Daniel McCauley.

The Christian and Elizabeth Ebersol homestead (left) as it appeared in 1993. The house in the foreground is the "Dawdy Haus" built on the Ebersol farm in 1876. Oral family history maintains Barbara painted the datestone (right) for the house. It has been painted over numerous times since the original was done and can no longer be clearly identified as her work.

Because of her tiny stature, children sometimes wanted to play with her. David Huyard, son of Isaac and Mary Huyard, remembered once as a youngster hiding her crutches when she stayed with his family. Elam Lantz, whose family lived on the Ebersol farm for several years, remembered his mother telling him he could not play with Barbara, who would have been in her sixties at the time.[12]

Evidently a person of high energy, Barbara was not slowed by crutches. A former neighbor, Enos K. Zook, recalled that she occasionally walked as far as several miles with her crutches.[13] Most people who remembered Barbara also talked about a little stool which she carried wherever she went. People called it the "Bevli *Benkli*" and said she used it in a number of ways. During church services, she propped her feet on it because the standard-height benches were so high her feet did not reach the floor. When working as a seamstress, she placed the stool on the treadle of a sewing machine. With her agile feet on top of the stool, she then pumped the machine. Often she also sat on the *benkli*.[14]

Barbara probably used various means of transportation. The Betsy Speicher letter suggested she attended a church service, which Betsy's mother also attended. The Speicher family then took her

along home to Hinkletown in their carriage. No doubt, she made such transitions frequently, but she may also occasionally have asked brother Jacob to deliver her to places with his horse and buggy. Whatever method of travel she used, it appears she covered most of the Lancaster Amish community at that time.

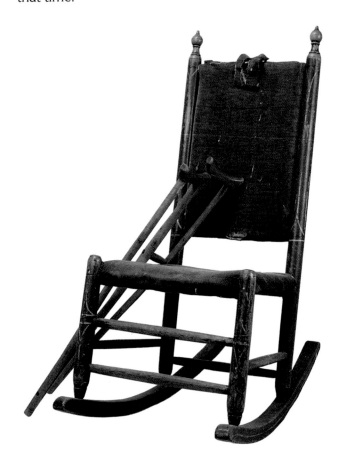

(above) The Ebersol family is well remembered in the Amish community for their love of hand-rolled cigars. These cigars were rolled by Barbara Ebersol and saved by one of her nephews. She enjoyed taking a break for a smoke. Collection of The People's Place.

(right) Because she was a dwarf, Barbara accumulated numerous special pieces of furniture. She used this small-sized rocker when visiting her sister Mary. Collection of The People's Place. Distance from floor to seat of rocker, 13⅜." Distance from floor to top of rocker back, 31¼." Crutches 30".

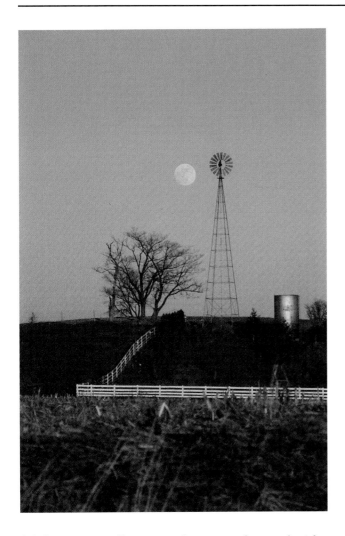

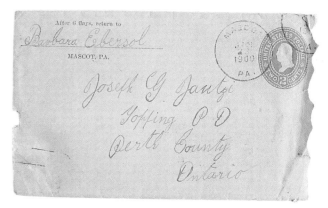

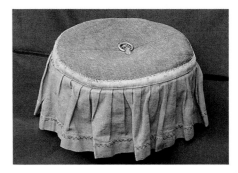

A full moonrise silhouettes a Lancaster County Amish windmill, symbolizing the sense of order so evident in many Amish homes. The Ebersol family was especially concerned with order.

(top) The Ebersol family had many friends and relatives in Ontario. Barbara sent this letter to the Joseph Jantzis in January of 1900. Collection of the Heritage Historical Library, Aylmer, Ontario.

(bottom) Oral history claims Barbara carried small stools such as this one with her wherever she went. Called "die Bevli Benkli" (the little Bevli bench), she was said to have used them to sit on or to prop her feet. Collection of The People's Place. 9" in diameter.

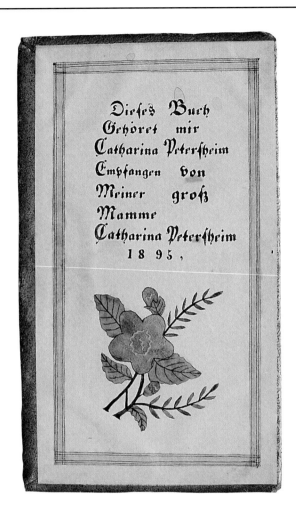

Dieses Buch
Gehöret mir
Catharina Petersheim
Empfangen von
Meiner groß
Mamme
Catharina Petersheim
1 8 9 5 ,

In 1895 Barbara Ebersol made a rail trip to Ontario to visit her relatives. Sometime that same year she also marked this book, containing the writings of Menno Simons (an early Anabaptist leader), for a Catharina Petersheim. Collection of The People's Place. 4" x 7⅛."

Another story about Barbara Ebersol maintains that she liked to go to Lancaster. After use of the trolley became widespread, she made the trek frequently. It is said she occasionally asked her nephew, John Speicher, to take her to the trolley station near his farm. One time he took her in his wheelbarrow.[15]

Barbara Ebersol also made at least one rail trip to Canada to visit relatives who lived in Ontario. In a letter dated January 27, 1895, Nancy Gingerich described a visit by some Pennsylvania folks to the Baden, Ontario, community where she lived. She said, "We were glad when we saw cousin Barbara." During Barbara's visit with the Gingerich family, Nancy and her brother drove Barbara to a hymn singing. Nancy wrote, "We had a nice singing there" and have not had "such a nice singing since."[16]

The Sources of Barbara Ebersol's Inspiration

The German settlers who came to southeastern Pennsylvania in the late 17th into the 18th centuries, practiced fraktur ardently. Schoolmasters often gave pieces called illuminated *Vorschriften* (writing samples which usually begin with decorative letters and continue with script) to their students as rewards of merit.[17] Families requested birth and baptismal certificates for their children. Young couples occasionally received wedding certificates upon their marriages. And people solicited artists to mark books, asking them to inscribe the inside front covers of their Bibles, testaments, or manuscript music books.

As was true with Pennsylvania German furniture,

fraktur reached the height of its use among the German settlers of southeastern Pennsylvania sometime between 1760 and 1830.[18] In the Franconia area near Souderton, schoolmasters of the Mennonite and Schwenkfelder faiths such as Christopher Dock, Jacob Oberholtzer, David Kriebel, and Isaac Ziegler Hunsicker painted hundreds of *Vorschriften* during those years. While Lancaster County Mennonites also produced some of these awards of merit, they were less prolific, more apt to sign their names, and more individual in their styles, thus creating relatively few classic *Vorschriften*. Also in Lancaster County, the sisters of the religious commune known as the Ephrata Cloister became internationally known for their delicate illuminated texts.[19]

The practice of fraktur was not limited to southeastern Pennsylvania. Mennonite artists such as Isaac Hunsicker and Anna Weber migrated to Waterloo County, Ontario, where they continued to paint. During these same years, hundreds of fraktur bookplates and *Vorschriften* also were created by artists in the transplanted Dutch Mennonite communities of south Russia.[20]

A widespread but nonetheless private art, fraktur paintings frequently celebrated one of the rites of passage in an individual life—birth, baptism, schooling, or marriage. Many artists literally filled the pieces of paper with complex designs, including hearts, angels, stylized birds and flowers, and carefully inscribed lettering, often enclosing the work in an elaborate border. The vast majority of Pennsylvania German fraktur pieces from the

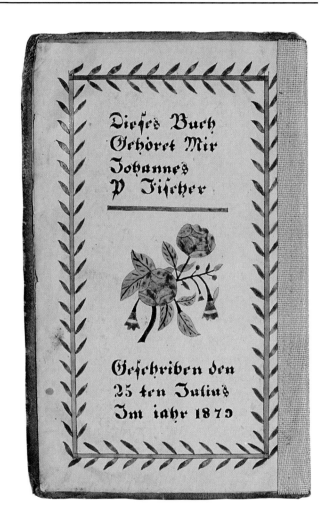

Barbara Ebersol painted this bookplate for a John P. Fisher on July 25, 1879 during what seems to have been the most productive period in her life. Collection of The People's Place. 3¼" x 5⅞."

43

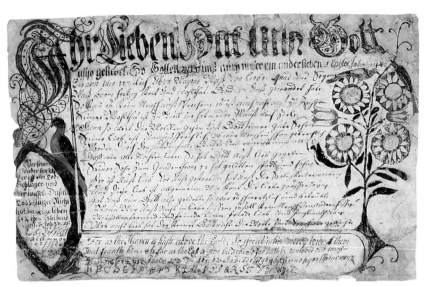

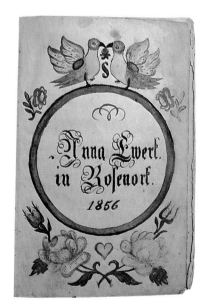

Three examples of work done by fraktur artists in the years when this art form was at its most popular (mid-1700s to the mid-1800s).

(above left) In the area around present-day Souderton, Pennsylvania, various schoolteachers are known to have created fraktur pieces. This is one of the few pieces which has been attributed to the well known Mennonite schoolmaster, Christopher Dock. Collection of the Mennonite Historians of Eastern Pennsylvania, Harleysville. 7¾" x 12⅛".

(above right) Members of the religious commune, called the Ephrata Cloister, became famous in the late 1700s for their delicate illuminations. This is one page from **Der Christen ABC** *in the collection of the Ephrata Cloister and Pennsylvania Historical and Museum Commission. 5⅛" x 5¾".*

(bottom right) Artists who lived in the Dutch Mennonite communities of south Russia also produced numerous fraktur pieces in the late 1700s through the mid 1800s. Collection of Anna Ewert's granddaughter. 4½" x 6¾".

1760s-1830s were birth certificates, baptismal certificates, or *Vorschriften*. Most of the artists were Lutheran, Reformed Church, Mennonite, or Schwenkfelder ministers and schoolmasters.[21]

Among the Amish the practice and acceptance of fraktur did not crystallize until the 1870s-1900s, when Mennonites and most other Pennsylvania German groups already considered fraktur an old-fashioned custom. Furthermore, Amish artists, including Barbara Ebersol, seldom painted either certificates or *Vorschriften*. This may have been because of the deeply held belief that sacred moments should not be trivialized. The practice of giving *Vorschriften* as gifts, quite common among many Mennonite groups at the time, never seemed to catch on among the Amish. Rather, they inscribed or marked books. Amish fraktur artists also designed calligraphic family records which were framed and hung in the formal parlors of the recipients' homes.

Barbara Ebersol attended school during the 1850s and 1860s when the creation of fraktur paintings had already started to wane, so she may have received only limited exposure to this art form in school. On the other hand, she may indeed have had a schoolmaster who encouraged her ability to draw and paint. Among her earliest known pieces

(right) One of the earliest known Barbara Ebersol pieces created for her brother David when she was only 14 years old and still attending school. Someone who later owned the book drew lines through Barbara's lettering. Collection of The People's Place. 3⅝" x 6".

are four bookplates dated 1860, when she was fourteen years old and still going to school.[22]

Another source of Barbara's inspiration may have been a member of her own family. One of her maternal uncles, Jonathan Stoltzfus, compiled a detailed math notebook in March of 1846 (see page 46.) Eighteen years old at the time, Jonathan enhanced the school notebook throughout with green, orange, and yellow fraktur lettering. Barbara

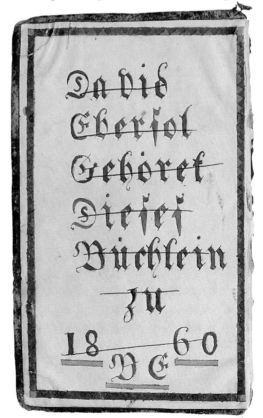

Ebersol used the same combination of colors in many of her early pieces.[23]

In addition to her Uncle Jonathan, Barbara Ebersol may also have been encouraged to continue her interest in marking books by people such as Frene Lapp. Frene Lapp was three years older than Barbara, and it is believed they may have been friends. Several books marked by Frene date from

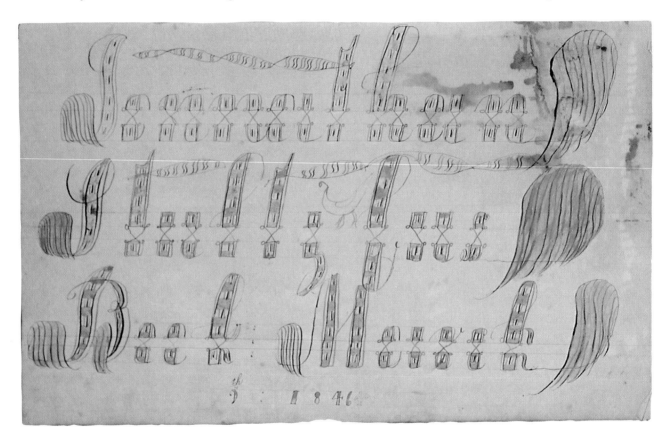

Many influences probably led to Barbara Ebersol's passion for marking books and creating fraktur paintings. This page from a math book, carefully copied and designed by her maternal uncle, Jonathan Stoltzfus, sheds some light on what may have been a family connection to fraktur painting. Collection of Kathryn and Daniel McCauley. 15" x 8".

circa 1870.[24] Her work appears to have been heavily influenced by Barbara Ebersol (see page 50).

A Measure of Barbara Ebersol's Talent

Whatever the sources of Barbara Ebersol's inspiration, the beauty of her bookplates, as well as the development of her own style, probably astonished both her family and her community. A woman of strong character with a well defined personality, Ebersol chose a collection of fraktur designs which she carefully repeated in an infinite array of combinations.

Some designs, such as her tulips, parrots, and Pennsylvania German barn motifs, were obviously borrowed from works she had seen. In fact, the one known human figure in her work probably was copied rather than composed. The image, which was also seen in some other Pennsylvania German folk art, depicts a soldier astride a horse. Among many Pennsylvania German people, an intense admiration for George Washington lingered through the first years of the 19th century. They reproduced versions of an 1833 etching of Washington crossing the Delaware in their own work. Ebersol either saw the etching itself, or she copied some other artist's interpretation of the piece.[25]

While she borrowed ideas from those around her, Barbara Ebersol also created a number of original motifs. Both the spiderweb rose and the popular striped or barber-pole border were her own patterns. The simplicity, careful layout, and pleasing design of her bookplates make her work instantly recognizable.

The only known human figure in Barbara's work, this horse and rider anchor one of the corners on the 1864 Anna Stolzfusz piece. Collection of The People's Place. 4" x 4½".

For example, the expertly crafted and well balanced bookplates of the Franconia-area Mennonite artist, Samuel Gottshall, have more white space than many of the other classic bookplates (see page 50). However, Gottshall's pieces are much fuller than the Barbara Ebersol pieces. Barbara's spacious style, adopted by a number of other Amish

The most unusual, and possibly the most carefully done, of all the known Barbara Ebersol pieces, this sampler was painted on a sheet of paper measuring 14¼" x 11". Barbara was 18 years old when she completed this piece. Collection of The People's Place.

Barbara Ebersol borrowed designs from other fraktur artists. She also created some of her own original patterns, such as the barber-pole border on the 1873 Fronica Miller piece (above, 4" x 7") and the spiderweb rose on the 1904 Johannes Speicher piece (left, 4¼" x 6¾"). Both in the collection of The People's Place.

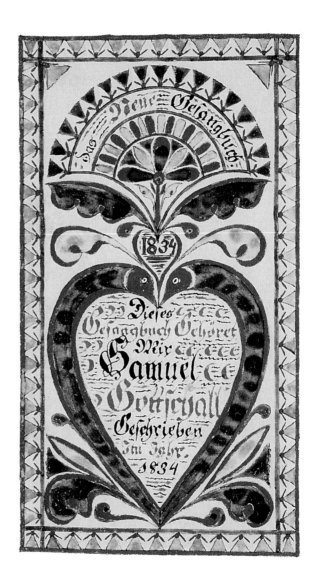

(above) This 1902 bookplate has been attributed to Frene Lapp. Lapp's work appears to have been heavily influenced by Barbara Ebersol. Collection of The People's Place. 3½" x 5¾".

(right) Samuel Gottshall bookplate. Collection of Mennonite Historians of Eastern Pennsylvania. 4" x 6½".

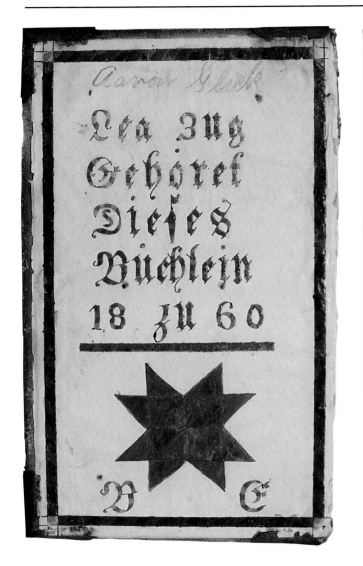

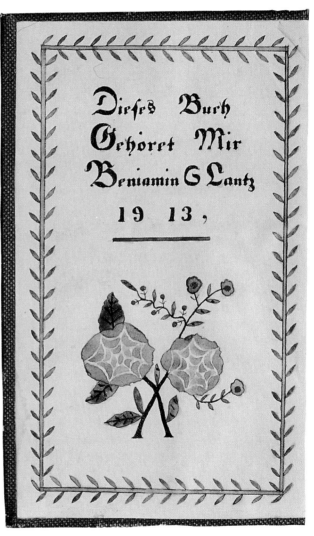

Fifty-three years separate these two Barbara Ebersol bookplates. Note the differences as well as the similarities. Both in collection of The People's Place. Lea Zug piece, 4½" x 7". Benjamin Lantz piece, 4¼" x 6⅞".

artists who also marked books, has been called "the Amish style."

Barbara's work may be separated by time periods: 1) Early years 1860-mid 1860s; 2) Young adult years 1867-late 1870s; 3) Middle years 1879-1890; and 4) Late years 1890-1922.

In the early 1860 pieces, she divided each bookplate into two sections. The top section usually has large, loose lettering, while the bottom section often features a Pennsylvania German barn motif, such as a colorful octagon or an eight-pointed star. Many of these pieces are signed "B E." (See Lea Zug

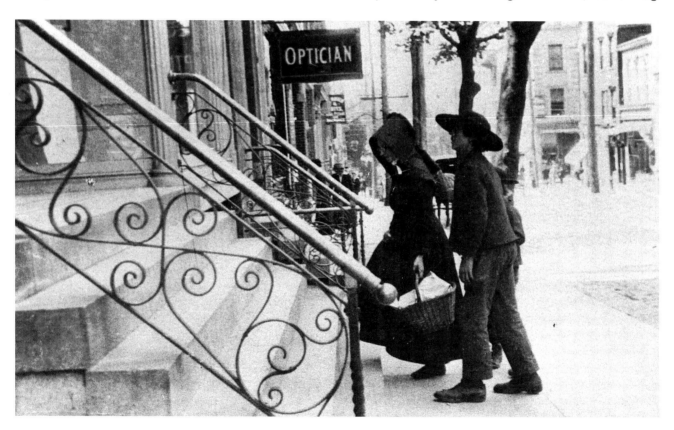

An early 20th century Amish woman visits an optician in the city of Lancaster with her two sons. It is said Barbara Ebersol enjoyed going to Lancaster, often traveling by trolley.

piece, page 51.) She occasionally signed the early 1860s pieces with her full name.

Around 1867 when she was becoming an adult, she began dividing the bookplates into three sections, divided by two bars. The images, which still always appear in the bottom section of the plate, are among her most interesting—a set of pears, a stately tulip, a geometric six-pointed flower, and a delicate wild rose. This period, when she signed many pieces with her full name, lasted through the late 1870s. (See page 35 for example.)

During the middle years of Barbara's life, she began to paint large bold flower images in the center of her three-part bookplates—the spider-web rose began making an occasional appearance. During this period, she also experimented a great deal with borders, producing numerous versions of a leafy border. She signed very few of the known pieces dated 1879 to 1890. (See page 43 for example.)

During the last years of her life (1890-1922), Barbara Ebersol reverted back to dividing the plates into two sections, with the lettering in the top half and the images in the lower half. The spider-web rose became her standby; most of the plates from this time period feature this classic Ebersol design. None of the known pieces from this period are signed. (See Benjamin Lantz piece, page 51).

It is fascinating to compare one of her 1860 pieces with a bookplate she completed in 1913 (see page 51.) Fifty-three years separate these two pieces. In 1860 she was a carefree thirteen- or fourteen-year-old girl with a long and full life ahead of her. In 1913 she was a sixty-seven-year-old woman, matured and marked by life.

The lettering on the 1860 piece (see page 51)—done for a Lea Zug—is a vibrant green and orange with a large, flowing adolescent looseness. By contrast, the lettering on the 1913 piece is much tighter and less colorful. Only in her early years did she use colored paint in the lettering as she does in the 1860 Lea Zug piece. Later, she began using black paint for calligraphy while still using color in the designs and borders. Furthermore, her hand became quite distinct, making it almost impossible to confuse Barbara's work with that of other artists who copied her style.

Several other features further distinguish Barbara Ebersol's art. She wrote in consistent German script, always spelling the word for belongs, *Gehoret*, with the single dot above the "o" instead of an umlaut (*Gehöret*), and the word for written, *Geschriben*, instead of *Geschrieben*. She also usually left a bit of white space between the second and third number in the designated year. For example, 18 67, 18 97, and 19 18.

In 1991 the Amish historian David Luthy noted an interesting development in the appearance of Barbara's signature on her pieces. He wrote, "During her early years as an artist (1860-1871) when she was 13 to 25 years old, she included either her initials or full name on 36 of 41 known bookplates [as in the 1860 Lea Zug piece, page 51]. During the next segment of her life (1872-1897) when she was 26 to 51 years old, she signed only 21 of 63 or exactly one-third [as in the 1873 Fronica Miller piece, page 49]. During the remaining years of her life

(1898-1922) she made all 23 known bookplates anonymously [as in the 1913 Benjamin Lantz piece, page 51]."[26]

Barbara Ebersol's understanding of community and humility as opposed to individual expression and pride probably developed over the years, making her ever more reluctant to give herself credit for a gift widely recognized and even celebrated by her community.

3.

The World That Formed Barbara Ebersol and Henry Lapp

The Family of Barbara Ebersol

Born on May 18, 1846 in Lancaster County, Pennsylvania, Barbara Ebersol began her life as the fifth child in an Amish home. Her family's oral history included the story of two courageous Swiss women, Catri and Elizabeth Aebersold. While it is not certainly known when the first Ebersols became Anabaptists (religious reformers with roots in the Reformation who are the forebears of today's Amish and Mennonite people), one Swiss record showed these two Aebersold women being forcibly deported from Switzerland around 1710-1712.[1]

Catri and Elizabeth Aebersold had joined the much hated and severely persecuted Anabaptists. They were among several groups of people who were first imprisoned and later shipped down the Rhine River, where they appear to have been rescued and taken in by Alsatian Anabaptists or Anabaptist sympathizers. These two stouthearted women are believed by some to have been foremothers of the Anabaptist Amish Ebersols who came to North America in the early 1800s, among whom were Barbara Ebersol's grandfather and father—Christian Ebersol Sr. and Christian Ebersol Jr. Barbara's mother, Elizabeth Stoltzfus, was a great-granddaughter of the Amish immigrant, Nicholas Stoltzfus, who had arrived in Philadelphia nearly a century earlier on October 18, 1766.[2]

Elizabeth Stoltzfus and Christian Ebersol Jr. evidently met each other and decided to marry during the time Christian Sr. and Susanna Ebersol lived in Lancaster County. According to a handwritten record held at the Muddy Creek Farm Library, the Ebersol family arrived in Lancaster County sometime in 1829. In 1832 they immigrated to Canada.[3] Christian Jr. either decided

55

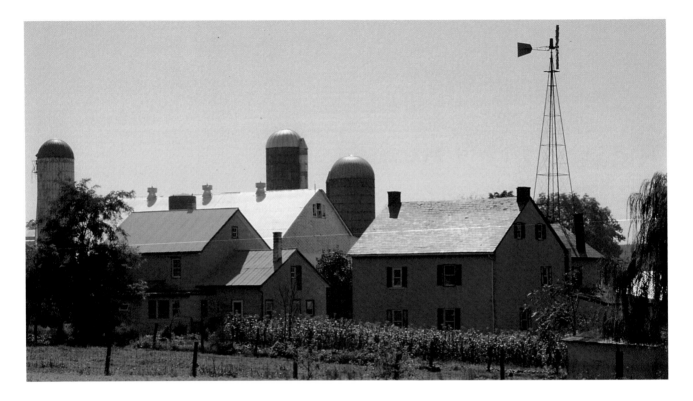

The Christian Ebersol Jr. farmstead as it appeared in 1993. The original Ebersol house (right) has been changed a great deal since it was built. Mill Creek flows on the south side of the barn and is not visible in this photo.

to return to Lancaster County or, perhaps, he chose not to leave with his parents and siblings. Early in 1837 he set up housekeeping with his wife Elizabeth on a 66-acre Leacock Township farm, nestled beside Mill Creek and near the center of what had become a thriving Amish community.[4]

The Christian Ebersol Jr. house stood along a winding country road in the Mill Creek Valley, the centerpiece of an immaculate Amish farm. A sturdy, three-story stone structure, it began to echo the songs and joys, the shouts and moans, and the sobs and whispers of the ten energetic children of Elizabeth and Christian Ebersol.

According to the 1860 census, all ten of the Ebersol children, from baby Catharine ("Katie"), age 2, to the firstborn Susanna ("Susie"), age 21, lived

While this piece is not dated, it is quite similar to the early Ebersol pieces (from 1860 through the mid-1860s). Collection of The People's Place. 3½" x 5½".

with their parents on a farmstead valued at $12,200, with $5,258 in personal property. The Ebersol sons—David, John, and Jacob—had tall, muscular frames. The daughters—Susanna, Elizabeth, Barbara, Mary, Sarah, Anna, and Catharine—were said to have been adept in various crafts, such as weaving, basketmaking, and decorative painting. Affectionately called "Bevli," Barbara, who inherited the genes for dwarfism, never matched her brothers and sisters in stature, but she outshone them all in creative expression. Still attending school at the time of the 1860 census, she was fourteen years old and had already created a number of fraktur bookplates.

A somewhat unusual Amish family of their time, the Ebersols were interested and involved in local affairs. Christian Ebersol Jr. emigrated from the Alsace Lorraine, a region which straddled the border between France and Germany and whose ownership had been disputed for centuries. At the time of Ebersol's departure, it was French. However, like most Mennonite and Amish inhabitants of the Alsace, he considered Germany his homeland and German his mother tongue. Evidently, he taught his children to revere the old country and to read and write the language of his forebears.

According to a collection of letters currently in the possession of an Ebersol family member, Barbara and most of her siblings spoke both English and German fluently. In a series of letters between two of Barbara Ebersol's nieces, references to Barbara and her sisters included requests to see the German letters which "the aunts write."[5]

Further, the Ebersols are remembered for their strong opinions and stolid grip on the old ways. As adults the Ebersol siblings insisted on wearing European Amish styles of clothing, rather than the more uniform styles that slowly developed among the North American Amish. They also often expressed dismay over what seemed to them a lack of reverence for history among their people.[6]

Christian Ebersol Jr. became very involved in the life of his new community. He filled a two-year term as the first road supervisor of Upper Leacock Township. In 1858, during a time when many Amish opposed education, he agreed to serve as school director of what was then the local public school system.[7] If he had opposed education, as many of his neighbors and friends did, Christian Ebersol certainly would not have held such a position. According to census records, the Ebersol children attended the local one-room school.[8]

The Family of Henry Lapp

About a quarter mile west and downstream from the Ebersol farm lay the sprawling farm home of Henry and Elizabeth Lantz. The Lantzes second child, Rebecca, was seven years old when Barbara Ebersol was born. Rebecca, who would become Henry Lapp's mother, and her younger sister, Elizabeth, may have skipped along Mill Creek to the Ebersol home many times to play with Barbara and her sisters.

When Rebecca Lantz married Michael Lapp—one of the sons of a large and affluent Amish family—on February 2, 1858, she moved across Mill Creek from her family home. The 1860 census indicated Michael and Rebecca Lapp owned their Leacock Township farm valued at $9,325. This census also showed four of Michael Lapp's six brothers— Jonathan, Samuel, John K., and Christian K.— owning farms in Leacock Township, each valued between $9,800 and $13,380. The sons of John and Fannie King Lapp, they were determined and successful farmers. Only ten years later the 1870 census declared significant increases in the values of each of their properties; they then owned farms ranging from $15,000 (Michael's) to $25,000 (Jonathan's). Rebecca Lantz married well.

After losing an infant daughter in 1859, Rebecca and Michael Lapp rejoiced a year later on the arrival of their second child, a daughter whom they named Elizabeth and called "Lizzie." Two years later on August 22, 1862, they welcomed their firstborn son, Henry, whom they called "Henny."[9]

The reasons for both Henry's and Lizzie's hearing impairments are unknown. Perhaps, their problems were created by an early childhood illness. Whatever the cause, the Lapp family evidently settled in to accept their children's communication difficulties and to make their lives as normal and happy as possible. Michael and Rebecca Lapp subsequently had four other children, all of whom had normal hearing.

The Mill Creek Neighborhood

One could stand on the north ridge above Mill Creek and look down over the farmsteads of the Christian Ebersol and Henry Lantz families. Following

(above) The Mill Creek Valley as it appeared in 1994. The barn and house in the left foreground are the Henry Lapp birthplace. The three silos and barn on the far right are the Levi Zook place. Directly behind the Levi Zook place one sees the peak of a barn with its silo—that is the Christian Ebersol Jr. place.

(left) Mill Creek near where it flows by the Ebersol farmstead.

the eye up the sloping south side of the creek, beyond what was the Levi Zook farm, one saw the Michael Lapp home with its unimposing house, surrounded by a large barn and other outbuildings. No doubt

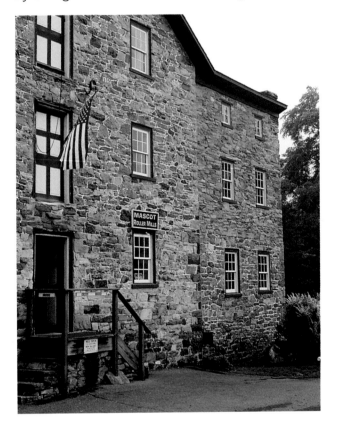

Christian Ebersol once owned a share in Ressler's Mill. Now called the Mascot Roller Mill, it still stands along Mill Creek, several miles downstream from the Ebersol home.

these Mill Creek Valley Amish farmers and their wives traded fellowship and labor, along with farm expertise and equipment. They probably attended each other's threshings and haymakings, Sunday morning church services and Sunday evening singings, watermelon feasts and taffy pulls, and weddings and funerals. No doubt, times of celebration mingled with times of support and pain.

Between 1860 and 1890, Christian Ebersol Jr. bought and sold various pieces of land in the Mill Creek neighborhood. At one time he owned a share in Ressler's Mill, which still stands along the creek at Mascot (formerly Groff's Store). Also, for many years the Ebersol family owned Eckert's Mill about a half mile east of their farm. When son Jacob bought the Eckert Mill property in 1889, the deed stipulated that $4,000 should remain for the use of Christian and Elizabeth Ebersol. On their deaths this money should go to daughter Barbara.[10] While the mill appears to have been an important part of the Ebersol family operations, the building eventually yielded to decay. It no longer stands.

Another deed dated November 30, 1867 shows the family owning a 35-acre mountain timberland tract on the Welsh Mountain in Caernarvon Township.[11] They also owned several farms and at least one residence other than their own in Upper Leacock Township. Christian and Elizabeth Ebersol appear to have been wise investors of their growing fortune. They provided a good living for their large family.

As their net worth increased, the Ebersols began making loans to their relatives, neighbors, and

friends. An inventory and appraisement of their goods taken at the time of Christian's death listed sixteen people to whom the Ebersols loaned money at 4½ percent interest. People owed the Ebersols principal amounts ranging from $50.00 to $4,000.00.[12] In his will, Christian Ebersol instructed his wife Elizabeth "to control and manage my estate in the same manner as I now control and manage the same, being careful to invest money at safe places and to make advancements to our children according to the manner and scheme as we have done."

He further directed "that four thousand dollars part of the valuation of my real estate, shall remain charged as a lien upon said farm during the life of my daughter Barbara, the interest thereof, at four percent per annum to be annually and regularly paid to her on or about the first of April of each year of her life."[13] This appeared to be the same $4,000 mentioned in the Eckert deed. Most likely Barbara's handicap and her father's concern that she might not be able to provide for herself explains why he singled her out for this special provision. Or it may simply have been that he believed Barbara less adept at managing her money than her other siblings. Evidence suggests Barbara Ebersol's strengths lay in her artistic genius, not in her business sense. Indeed, one of Barbara's great-nephews, John M. Ebersol, remembered that "she could not figure well."[14]

The Ebersol children inherited their parents' wealth and continued to make loans, although not always willingly. Esther Fisher, granddaughter of Barbara's brother David, remembered being asked

Barbara Ebersol completed this bookplate for her sister Anna in 1874 when Barbara was 28 years old. During these years, possibly among the happiest of her life, Barbara lived on the family farm with her parents and siblings. Collection of The People's Place. 3¼" x 5⅝".

61

by her own parents to visit "the aunts" to report on a recent trip she had made to the Ontario relatives. Barbara looked at her and in her characteristic "Germanic Pennsylvania Dutch" made the following comment, "You young folks can spend your money for traveling but you'll have to hang your head when you come to ask for money."[15]

Another story, still sometimes repeated in the Amish community about the Ebersols and their money, tells of a young Amish man driving into the Ebersol lane late on a spring evening. When Jake Ebersol heard the knock on the door, he appeared at his upstairs bedroom window and shouted, "We're in bed, and you can't have any anyway."[16]

So the Ebersol family earned their reputation for being shrewd, blunt, and curt. How fair that was may certainly be weighed against the memories of those relatives who recalled them with great warmth and

Farm life was central to both the Ebersol and Lapp families. Signed on the back, "Henry Lapp, 1879," this painting demonstrates Henry Lapp's understanding of farm life. Collection of Bob Hamilton. 6" x 3½".

affection. Mary Ebersol Lapp, called "Mummy Mareili" by her grandchildren, spent hours laughing and talking with her daughter Fannie and the grandchildren with whom she lived.[17] Sarah Ebersol King loved to tease; her grandson, Moses Blank, said, "I would say she was jolly."[18]

In November of 1896, one of Barbara's nieces described an evening spent with Aunt Barbara, "On Sat. evening we got company Betsy Katie and Sam

These two Lapp paintings demonstrate the wide variety of subjects that interested Henry and Lizzie Lapp.
(left) Signed "Henry Lapp 1876." Collection of Bob Hamilton. 4¾" x 4¾".
(right) Signed "Elisabeth Lapp, March 30, 1873." Collection of The People's Place. 4" x 6⅜."

King and Aunt Barbara were here and we had fun and sang awhile."[19] Enos K. Zook, whose grandparents lived across Mill Creek from the Ebersols, said, "They were quite nice to be around although they could be a bit headstrong and did not take advice too willingly."[20] Evidently, the Ebersols believed in protecting their investments, being curt and blunt about finances when they needed to be.

By the time of the 1880 census, Michael and Rebecca Lapp with their six children—Lizzie, 19; Henry, 17; Sarah, 15; Daniel, 13; Fannie, 10; and Rebecca, 7—were well established on their Leacock Township farm on the opposite side of Mill Creek from the Ebersol farm. The four younger Lapp children were still attending school, while Henry and Lizzie apparently assisted with the daily operations of their busy farm life.

An 1880 account book kept by C.D. Buckwalter in the village of Groff's Store (Mascot) shows the Lapp family made weekly trips to his general country store, where they purchased anything from sugar, candy, and raisins to sewing supplies and velvet. On September 24, 1880, someone in the family bought a pair of shoes for $1.87. The week before Christmas the list included such exotics as figs, dates, mints, and two dozen oranges. The book also contains a running record of products which the Lapp family brought to the store to trade—eggs, butter, tobacco, apples, walnuts, and chickens. On February 26, 1881 when the 1880 account was balanced, Michael K. Lapp owed C.D. Buckwalter $14.40 which he paid in cash.[21] Those were good years for Michael and Rebecca Lapp and their six children.

Tragedies Strike
the Lapp and Ebersol Families

Three and a half years later, at 6:30 on an August evening in 1884, Michael Lapp died at the age of fifty-three, the victim of a heart attack.[22] According to records kept at the Lancaster County Courthouse, he had failed to make a will. Consequently, on September 4, 1884, Michael's brother-in-law, Benjamin Lantz, along with an Isaac Lapp and a John Kauffman, appeared at the Registrar's Office in Lancaster where they gave a detailed list of "the goods and chattels rights and credits" of Michael K. Lapp. The inventory list included his animals, crops, and farm implements, as well as nine bond loans he had made to various members of his community. The loans ranged in principal amounts from $400 to Elias K. Stoltzfus to $4,000 to B.K. Smoker. The total appraisal of Michael Lapp's inventory amounted to $15,304.73. Adding the value of his real estate, declared to be $15,000 in the 1870 census, Benjamin Lantz then listed Michael Lapp's total worth as $30,000.[23]

As administrator of the estate, Lantz spent almost a year and a half collecting the money owed. On February 13, 1886, he appeared again at the Registrar's Office with a carefully compiled list, showing exactly what had been paid into and out of the estate.

The Lapp farm continued to prosper during those years of adjusting to the loss of their husband and father. The Lantz account report showed the Lapps selling produce, crops, an occasional animal such as a calf or a hog, and even some stone and a cord of

wood. Benjamin Lantz also reported the payment of a variety of bills, including $15.00 to Peter Sowers undertaker, $3.35 to J.D. Buckwalter telegraphing, and $1.00 for a subscription to *Herald of Truth*, a 16-page semimonthly paper on Mennonite spiritual life read by many Amish people.[24] According to the accounts and records' report, the Michael Lapp estate was settled in the Orphans Court of Lancaster County on February 11, 1886, abundantly providing

for Rebecca Lapp and her children. They stayed on the farm. By 1890, Henry Lapp's mother had taken primary responsibility for the farm operations, while Henry spent much of his time building furniture.[25]

In the 1880s a succession of tragedies also hit the Ebersol family. Early on a July morning in 1881, Barbara's brother John committed suicide. The *Lancaster New Era's* report of the story speculated, "One reason given for the suicide is

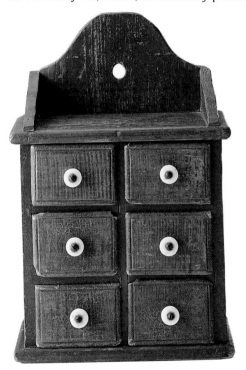

A small seed drawer and a sewing chest, both built by Henry Lapp, circa 1880. Collection of The People's Place. (left) 8¼" x 4½" x 12". (right) 7⅝" x 6¼" x 4⅜".

Dieses Buch
Gehöret Mir
David Ebersol

Geschrieben den
20 ten Julius
Im iahr 1881

Two weeks after the untimely death of her brother John, Barbara painted this piece for her brother David. She also painted a similar piece for her father Christian at the same time. Perhaps it was a way for her to deal with her grief. Collection of The People's Place. 3¼" x 5¾".

that he was an endorser of a note for $500 which he feared he had to pay, making him despondent. Another rumor is that reports affecting his virtue were circulated and he feared the discipline of his church."[26] Legal records indicated John Ebersol may have been experiencing financial difficulties.[27] Whatever the cause of his rash act, he left behind his grieving wife, Mattie, and three small children: Isaac, age five, Andrew, age three, and Fannie, age one. His untimely death must have been a crushing blow to the close-knit and demanding Ebersol family.

About a year later, a diptheria epidemic swept through the Amish community. Near the end of April 1882, it claimed five-year-old Jonathan and four-year-old Daniel, the two young sons of Barbara Ebersol's sister, Mary, and her husband, Christ Lapp. They were buried side-by-side in the Amish cemetery near Gordonville, only about a mile from their Irishtown Road home.[28]

Five years later, on March 9, 1887, 47-year-old David Ebersol, Barbara Ebersol's oldest brother, died after a long illness. A successful farmer who had purchased a farm in the Groff's Store area near Ressler's Mill, David Ebersol had written a will that included the unusual request that none of his wife Esther's sisters should ever be permitted to move in with her. Stating that he held no ill will against them and that they should feel free to visit, he simply asked that they never live there permanently because "I fear they will persuade my children to pride and from the form of the Amish worship."[29] Given the fact that the 1880s were turbulent times for the Amish

community, Esther Riehl Ebersol's two single sisters, Fannie and Nancy, may have sympathized with the group who eventually broke away from what became the Old Order Amish church. David Ebersol, on the other hand, was a staunch supporter of the Old Order Amish.

The Larger World of Their Childhood Years

According to one local weekly newspaper, *Lancaster Examiner and Herald*, the May when Barbara Ebersol was born passed in rather uneventful fashion. The newspaper's front page carried announcements for the English translation of a new book by Alexander Dumas, a magic salve called McAlisters All-Healing Ointment, and the opening of "a seminary for the education of young ladies." News about the far-off Mexican War and General Zachary Taylor filled pages two and three. However, in a letter dated May 11, 1846, a correspondent from Harrisburg wrote, "There has been cloudy and rainy weather for a week. The Susquehanna is rising very fast and is about 12 feet above low water mark. It seldom rises above 16 feet." Mill Creek, which empties into the Conestoga River, a tributary of the Susquehanna, probably ran high and fast past the Ebersol farm on Monday, May 14, while Elizabeth Ebersol labored to bring her fifth child into the world.[30]

During the first years of little Bevli's life, sometimes called the "Fabulous 40's," James K. and Sarah Polk lived in the White House. Known for her intelligence and devout religious faith, Sarah Polk was also deeply

The railroad became an integral part of Amish life. Late 19th and early 20th century Amish used it extensively for travel and commerce.

involved in her husband's political life. The Polks presided over the age of Emerson and Thoreau, the discovery of gold in California, and the annexation of huge amounts of territory.

Historians are sharply divided about the success or failure of James K. Polk's presidency. Occasionally called "one of the very best," he was also accused of ignoring the problems of child labor, immigrant poverty, and slavery. Conditions that refused to disappear, these issues created havoc in later years. But in the 1840s and 1850s, many Americans rode the crest of success.

The Lancaster County of those years was a flourishing community, witness to rapid growth and electrifying change. The Philadelphia to Columbia Railroad had been running for almost 15 years at the time of Barbara Ebersol's birth. Built through the heart of the Amish community, the iron road and its

Several groups of Amish people crossing a street in downtown Lancaster in the early 1900s. The Ebersol and Lapp families occasionally traveled to Lancaster from their rural farm homes.

horses resonated with the pulse of Amish life and, interestingly, became the one form of modern transportation never rejected by the Amish church as too worldly.

In his history of Lancaster County, Frederic Shriver Klein wrote, "The 1850 decade proved to be one of the periods of swiftest growth in the history of the county. The most far-reaching of all the changes took place in the field of agriculture. By the end of the decade they [farmers] had become mechanized through newly invented tools, organized through agricultural societies, and specialized by the rapid introduction of tobacco culture." Klein also noted the explosion of new buildings in the county seat, also called Lancaster—"new court house, new jail, new market house, new reservoir, opera house, a

college."[31] The Lapp and Ebersol families occasionally traveled to the city of Lancaster, and they may have been affected by its energy and life. Their lives, indeed, were influenced by the rapid advances in the field of agriculture.

Cyrus McCormick demonstrated the first reaper in 1831, and Hiram and John Pitts invented the first threshing machine in the early 1830s. By the late 1890s, few North American farmers still harvested grain by hand. In 1837 John Deere created his first steel moldboard plow out of a circular saw blade. By 1855, more than 370 patents for changing and improving plows had been issued by the United States Patent Office.[32]

Tobacco became the primary cash crop in Lancaster County by 1850, and smoking cigars was soon a popular form of relaxation. By 1891, Lancaster County farmers were producing hundreds of thousands of pounds of tobacco each year.[33] Amish farmers, including Christian Ebersol and

The burning of the Wright's Ferry Bridge over the Susquehanna River during the Civil War.

Michael Lapp, were buying these newly invented farming tools and were among the most successful of the county's tobacco farmers. The Ebersol family was well-known in the Lancaster Amish community for their love of hand-rolled cigars. In the days before smoking was considered harmful, they spent many an evening relaxing over a smoke.[34]

By August 22, 1862, the day, Rebecca Lantz Lapp gave birth to her firstborn son, Henry, the United States had become embroiled in a fierce Civil War. Less than a month after little Henny's birth, the Southern army entered Maryland with 50,000 troops. One Lancaster newspaper wildly asserted, "The rebel hordes have invaded and are desecrating the soil of Pennsylvania. If they once fairly penetrate our State, the charred walls of Hell itself, could they be made to speak, could reveal no such horrors as these Southern hordes will perpetrate upon our soil."[35] Actually, the "Southern hordes" were attacked near Sharpsburg, Maryland, on Antietam Creek and retreated with enormous loss of life—12,500 Northerners and 11,000 Southerners.

On July 1, 1863, when Henry Lapp was nine months old and Barbara Ebersol had just turned sixteen, the Confederate Army finally made it to Pennsylvania. On a straight course for Lancaster, one division got as far as the Lancaster and York County line—the Wright's Ferry Bridge on the Susquehanna River. The immense, wooden covered structure was quickly burned, stopping the forward march. Attacking and counterattacking around the hills of the small town of Gettysburg (about 40 miles west of the river), the two armies spent three days fighting in the sweltering July heat. The Susquehanna River proved an impassable geographic boundary, making the war seem far away from most Lancaster Amish, many of whom lived at least 20 miles east of the river.

However, concern over the war was a very present and palpable part of Lancaster County life. The outcry for people to join the fight had reached a fever pitch in late 1862. On October 16, 1862, the first draft of able-bodied men in Lancaster County was held at the Orphans Court. While draftees could purchase substitutes, they often requested exorbitant sums. Without a doubt, Amish men, perhaps including Barbara Ebersol's two draft-age brothers—David, 23 and John, 18—were affected by this call. On July 15, 1863 (only ten days after the battle at Gettysburg), a national draft law went into effect, providing exemption by the payment of $300 for those opposed to the war. In Lancaster County, 1,214 men paid the commutation fee at $300 each.[36]

While not as traumatically affected as their Mennonite cousins in Virginia's Shenandoah Valley, Lancaster County Amish shared in the pain created by the war. They and their Mennonite neighbors were the subject of an ongoing dispute among the three local newspapers, one of which asserted that the "rich Mennonite farmers" must also help finance the war or not be surprised if their farms were the first to be overrun. Another paper expressed frustration that a Strasburg-area Mennonite church had decided not to contribute money and not to let its young men join the militia.[37] The Lapp and Ebersol families were somewhat isolated from the actual fighting, but they must have been affected by the opinions of their

friends and neighbors.

Further, the developing turmoil in the Amish church itself created disagreement and unrest in their community. Members held differing points of view about the war, along with an array of other issues.

The Amish Church of Their Childhood Years

Many Lancaster County Amish in the first sixty years of the 19th century were caught up in the affluence of the world around them. While a roaring "golden age" of prosperity covered serious ills in the world, Amish leaders of the time had premonitions of a similar thin layer of success in the church.

Before the 1800s, the Amish church in North America had been somewhat loosely held together. In 1809, the Berks-Chester-Lancaster Amish settlement held its first ministers' meeting. A document called the "Discipline of 1809" resulted. It dealt with a number of concerns, including shunning (disciplining members who left the church), personal adornment, and serving on juries.[38] Efforts to strengthen the authority of the church became a central focus in the Amish community during the childhood years of Barbara Ebersol and Henry Lapp.

Quite often, differences of opinion arose because of the diverse experiences of those Amish who had left Europe in the early 1700s and a new group of Amish immigrants who began arriving in the 1830s. These later arrivals had been shaped by almost another century of life on the European continent. In Lancaster County, most of the church leaders were firmly entrenched, native-born Americans. In contrast, many of the other Amish communities, such as the Ohio, Indiana, and Illinois settlements, and the one in Ontario, where Barbara Ebersol's grandparents lived, ordained men who were new immigrants. Controversies arose over whether or not baptism should take place in a stream and involve immersion, whether or not shunning should continue to be rigidly enforced, whether or not persons baptized in the Mennonite church had to be rebaptized before joining the Amish church, whether or not dating couples should engage in the age-old practice of bundling, and whether or not Amish farmers should, without deliberation, accept the overwhelming technological changes of the day.[39]

As these issues swirled around the homes of the Ebersol and Lapp families, life went on. No doubt their Amish homes sparkled with energy, perhaps occasionally divided as they discussed the prevailing questions facing the church. They were probably among the families targeted by Bishop David Beiler in an 1862 writing, lamenting the progressiveness of the Amish church in the early 1800s. In addition to expressing concern over the sumptuousness of Amish meals, the elaborate home furnishings, and the splendid houses and barns, he complained that children went to school every winter for months at a time. In this 1860s reflection on life in the Lancaster Amish community, David Beiler also said, "It was a good time according to material things. The old people became rich. The young people tried to carry on high and to imitate the fashions of the world."[40]

As the world crept into the Amish community, church leaders expressed increasing concern. Large

 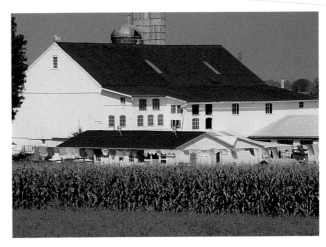

"Splendid barns" have been a mark of the Lancaster County Amish community since the earliest years of the settlement. The barn built by Christian Ebersol Jr.(left) and the barn at the Henry Lapp birthplace (right) as they appeared in 1994.

families and the influx of immigrants sparked growth. By 1860 there were four growing Amish church districts in Lancaster County—Pequea, Conestoga, Upper Pequea, and Mill Creek.[41]

Through the 1860s, the fires of dissension slowly began eating away at the unity of the church. While Amish communities in other parts of North America split or disintegrated, sometimes over personality clashes, the voices of reason in Lancaster County managed to predominate well into the 1870s. However, two of the districts—Conestoga and Pequea (later called Lower Pequea)—experienced ongoing trouble. Their leaders sometimes disagreed with each other and more often disagreed with other Lancaster Amish, most of whom adamantly

supported the conservative factions in the scattered Amish communities.

In his 1862 lament, David Beiler expressed his belief that God would chastise people, "perhaps with war and strife and bloodshed, of which there appears already to be a beginning." He pled earnestly for people to repent from their high living ways, underscoring his concern that God might be using the war to punish the church for straying from the simple ways of the forefathers.[42]

Perhaps some Amish shared Beiler's belief and saw a parallel between the heart-wrenching circumstances propelling the nation into war and the growing dispute within the Amish church. Amish leaders, including David Beiler, began calling for a

churchwide gathering to work at solving the complex problems which were preventing Amish unity. The first such yearly meeting convened on June 9, 1862 near Smithville, Ohio. Only a few Lancaster County ministers ever attended the meetings held annually through 1878.[43] Perhaps the war made it difficult for them to travel in the early years (1862-1865).

In late May 1863, when the group met near Belleville in central Pennsylvania (about a month before the Civil War battle at Gettysburg), the encroaching war became the focus of an afternoon of discussion regarding the holding of political offices. One person suggested it was "very unseemly for someone who professes nonresistance in faith to go to political meetings with a big mouth." After much discussion with amazingly similar opinions, the group decided unanimously that any offices which required the delegation of force (criminal or military) were strictly forbidden. Further, anyone who enrolled in the militia should be excommunicated. The official Amish position during the Civil War was clear and united—no members were permitted to bear arms.[44] In fact, it was one of the few issues the wider church body agreed about during this turbulent time.

There were several other subjects which created discussion during these meetings, but one particularly prickly one kept surfacing—the debate about whether a person who had been baptized in the Mennonite church needed to be rebaptized if he or she desired to join the Amish church. While nearly two centuries had passed since the 1693 separation of the Amish church from the Mennonite church in

Europe, differences of opinions and life understandings continued to plague their New World communities. They lived as neighbors. They held similar religious convictions. Their young people became friends in the local schools.

What happened when two persons—one Amish and one Mennonite—fell in love and wanted to marry each other? Traditionally-minded Amish, such as David Beiler and John K. Stoltzfus, bishops

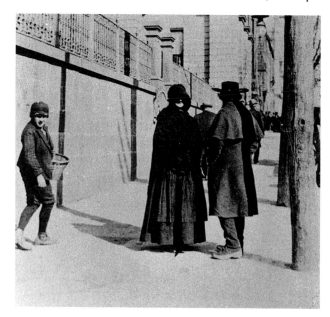

In 1864 the Lancaster Amish community declared its desire to be separate from the larger society. Nearly fifty years later, an Amish man and woman in front of the Lancaster County Courthouse are clearly different from those around them in both manner and dress.

of the Upper Pequea and the Mill Creek congregations to which the Lapp and Ebersol families belonged, held that both must become members either of the Mennonite or the Amish church. If they decided to be Amish, the Mennonite spouse must be rebaptized. The Lancaster County conservative arm of the church held firmly to this belief, making marriages between Amish and Mennonite young people in Lancaster County more and more rare.[45]

In April of 1864, when Henry Lapp was a year and a half old and Barbara Ebersol was awaiting her eighteenth birthday, the Amish leadership of Lancaster County decided to hold a meeting independent of the larger church conferences (by now called *Diener Versammlungen*). One of the opinions rendered at this separate April 1864 Lancaster meeting and recorded by David Beiler had far-reaching effects on Lancaster County Amish life. "We agree further that we hold or consider education [in the original, *die Hochgelehrsammkeit,* which literally translated means, higher learning], Sunday schools, showy clothes, fancy vehicles, and so on as harmful."[46] Many Lancaster County Amish did not oppose receiving a basic elementary education. However, they did oppose "higher learning." The decisions against higher learning, Sunday schools, showy clothes, and fancy vehicles helped establish clear distinctions between the main body of Amish in the Lancaster area and their Mennonite neighbors and friends.

It may be argued that during Barbara Ebersol's formative years and Henry Lapp's early childhood,

Lancaster County's Amish and Mennonite people lived similar lives, sometimes making it difficult for local society to distinguish between the two groups. Members of both groups used modern farm equipment, held local offices, drove handsome horses and carriages, and kept beautiful farmsteads. In reality, however, these two religious cousins had been shaped by very different forces for nearly two centuries.

Beginning with the 1693 division in Europe, when Jacob Ammann and his followers made it clear that they believed Mennonite thought and practice, regarding such doctrines as shunning and communion, needed reform, the Amish church consistently took different positions from the Mennonite church on a wide range of doctrinal issues.[47] The life-style decisions made by the main body of the Lancaster Amish church in 1864 slowly began to make those differences more apparent.

The Larger World of Their Adult Years

In the final years of the 19th century, the city of Lancaster and the county which surrounded it bustled with activity, going through periods of invigorating growth followed by slides into decay. An early 1870s report by the Lancaster Board of Trade claimed the city "has been the subject of ridicule by more earnest and progressive towns." It also attacked "our want of sufficient and good hotel accommodations, our filthy streets, our poor public buildings for municipal purposes, our want of proper market accommodations, and in fact the want of public improvements of all kinds."[48]

A twenty-year period of intensive growth exploded

on the heels of this scathing report—making possible the remodeling of the Fulton Opera House; the establishment of several major hotels, including the elegant Stevens House and the Hotel Lancaster; the phenomenal construction of five major market houses, including the venerable Central Market; the first years of what became important department stores, including Watt and Shand and F.W. Woolworth; and the construction of Victorian architectural facades along the entire south side of the first block of East King Street. Consequently, an 1896 Board of Trade report painted a very different

Two Amish women and an Amish man stand in front of Lancaster City Hall in the early 1900s. The woman on the far left is Mennonite. Note the subtle differences in manner and dress between the Amish women and the Mennonite woman. One of the Central Market spires is on the far right.

A watercolor drawing of a little house in Henry Lapp's furniture catalog. One researcher believes the design may have been inspired by a visit to the 1876 Centennial Exposition in Philadelphia.

picture of Lancaster and its surrounding area: "Lancaster is situated in a wealthy agricultural area where the cost of living is low and the standard of comfort is high." The report further claimed Lancaster's banks were "as sound as the Rock of Gibraltar," its water supply pure, and its fire department first class.[49]

In 1876 when Henry Lapp was thirteen and Barbara Ebersol had just reached her thirtieth birthday, many Lancastrians were consumed with the

excitement of the Centennial Exposition in Philadelphia. Teachers encouraged students to prepare artwork, penmanship, and other achievements for display. Leaders of local industries and local farmers sorted over their best productions and livestock for exhibition at the exposition. No doubt, there were some Amish people who traveled to Philadelphia for the festivities.

In fact, in her attempt to understand Henry Lapp's inspiration for the design of a dollhouse found in his furniture sketchbook, Beatrice B. Garvan, formerly of The Philadelphia Museum of Art, wrote, "It might be a barn or a castle—or perhaps Henry Lapp had visited the 1876 Centennial Exposition and was inspired by one of the exotic pavilions."[50] Since Amish of the late 19th century used rail travel extensively to visit relatives and friends and to attend church meetings, the suggestion that the affluent Leacock Township Michael Lapp family attended the Centennial Exposition is certainly within the realm of possibility. It may have been one source of the intense stimulation so evident in paintings done by Henny and Lizzie Lapp.

In 1891, Lancaster's Conestoga Traction Company inaugurated the era of electric railway transportation. By 1910, 150 miles of rural trolley lines connected such outlying villages as Soudersburg, Paradise, Gap, New Holland, Strasburg, Akron, and Ephrata to the city of Lancaster. Many of these lines passed through the heart of the Lancaster County Amish community, and Amish people became a common sight on the streets of Lancaster at the turn of the century. On April 30, 1891, twelve-year-old Betsy

Speicher of Hinkletown journeyed with her sister, Nancy, to the city of Lancaster for a dental appointment. In a letter dated May 8, 1891, Betsy says, "I seen a lot of cars...that was the first time I ever was on the cars." The new invention made quite an impression on young Betsy, for later in the letter she tells her friend Sarah, "When I come down then we can gabble as fast as the cars can run."[51]

Various members of Barbara Ebersol's family made occasional trips to Lancaster to negotiate their business dealings. Father Christian, mother Elizabeth, and brother Jacob frequently appeared before one or another official at the Lancaster County Courthouse to sign papers such as deeds and wills. On their trips to Ontario to visit relatives, they probably passed through the Lancaster train station located on the northeast corner of Queen and Chestnut Streets near the heart of the busy city.

In fact, the Nancy Gingerich letters in the Sarah Lapp Zook collection note that members of the Ebersol family made several visits to the Baden, Ontario, area between 1892 and 1896. Traveling to Canada were Jacob Ebersol, Elizabeth Speicher (Barbara's sister), Barbara Ebersol, and Mattie Ebersol (Barbara's sister-in-law).

The 1890s marked the peak years of the powerful prohibition movement in the United States. Exhibiting a revivalist zeal, supporters of prohibition traveled around the country urging total abstinence from alcoholic beverages. In his *Lancaster County Since 1841*, Frederic Shriver Klein mentioned one such visit to Lancaster County. "Miss Ellen E. Eldred, an emulator of Mrs. Carrie Nation, the saloon

smasher, is in Lancaster." In March of 1901, Eldred delivered a temperance speech in front of a local barroom.

Many Lancaster County Amish of the time registered considerable skepticism about prohibition. For the most part, they accepted moderate use of both alcohol and tobacco. In fact, some Amish even made their own beer and wine. On July 5, 1893, Betsy Speicher described her day to

Sometime in 1890 Henry Lapp made this amusing ink sketch for his good friend Joel Beiler. Both men were in their late twenties at the time. Collection of the Muddy Creek Farm Library. 5⅞" x 5⅞".

Sarah Lapp, "We made wine. And we have beer and honey and if youns come up you will get some you dare not wait to long unless you won't get no beer." Five years later, on a July Sunday in 1897, Betsy again told Sarah, "Tomorrow we are going to make beer. Do you like it I like it if you come you will get a drink if not stay at home."[52]

In a 1924 history of Lancaster County, H.M.J. Klein credited the Amish church for excommunicating members who engaged in excessive and harmful drinking habits, but also said, "This church never has taken a strong position on the doctrine of temperance."[53]

The Amish Church of Their Adult Years

In his articulate and sympathetic portrayal of Lancaster's Amish community at the dawn of the 20th century, H.M.J. Klein also declared, "One of the most outstanding features marking the conservatism of the Amish manifests itself in their personal appearance and manner of dress." He further described the dress styles of Amish men—their clothes were homemade of plainly colored material, they wore homemade suspenders, they used hooks and eyes rather than buttons, and they were required to wear beards and not permitted to wear mustaches. Women, Klein wrote, always wore aprons, capes over their shoulders, homemade dresses of different solid colors, shaker-type plain bonnets as "shelter-coverings," and white caps made out of muslin as prayer coverings.

Klein also commented on Amish beliefs: "They stand strongly opposed to higher education, but are in sympathy with elementary training, they practice the doctrine of non-resistance, they accept only the marriage of members within the church, and they still practice the doctrine of avoidance or shunning although not quite as severe in their method of discipline as in earlier years."

Concluding with several short paragraphs describing Amish weddings and funerals, Klein wrote, "On the charge that they are rather clannish in their attitude toward other folks, there is small ground for defense, since the very nature of their practices tends towards this end."[54]

4.

How Being Amish Nurtured Henry and Barbara

Being Amish in the Late 1800s

In the late 19th century world of Barbara Ebersol and Henry Lapp, Lancaster County Amish viewed their lives and the world around them through the lenses of their closely-knit community. They loved and laughed and rejoiced. They were angry and cried and grieved.

Children celebrated friendship. In 1887 two twelve-year-old friends, one of whom was Barbara Ebersol's niece, wrote to each other, "Uncle Davids children were here a wile and we had very much fun and I wished you were here too." A year later another friend joined in the letter writing, telling about a school experience, "I have got your piece of paper that Katie painted a girl on it dont you know that she gave me one and you one and Levina one. I guess you left it in school."[1]

Young people fell in love. A fourteen-year-old girl met the eyes of a fourteen-year-old boy in 1890. "I went with cousin Sallie Fisher. Stephen Ash was there to. Sallie told me which was him she had to laugh when she looked at him and he laughed when he looked at her. I believe that she loves him for she is just all the time talking about him."[2] Six years later on November 26, 1896 Sallie Fisher married Stephen Esh.[3] It must have been love at first sight.

Families encountered pain and personal suffering. In a December 4, 1892 letter, Sallie Fisher included the story of one young woman who faced some difficult choices. "I guess you know about Annie Kauffman and Cos Stoltzfus . . . John here was at Paradise then he heard there was something wrong with Annie Kauffman. And they just said such a mess among the Amish, mind the English [the term used by Amish people when referring to anyone who was not Amish] ones. I heard Annie said she will go away when Suvilla

has her wedding, I think it must be awful hard."[4]

Sallie Fisher chose not to be specific about the nature of Annie Kauffman's and Cos Stoltzfus's problems. However, according to the *Fisher Family History*, Annie Kauffman, who was twenty years old in 1892, and whose sister Suvilla was married on December 22, 1892, married twenty-two-year-old Ezra Stoltzfus, who went by his nickname "Cos." Evidently, Annie Kauffman had become pregnant before their marriage, for their first child was born on April 9, 1893, only four months after Sallie Fisher's gossipy letter to Sarah Lapp.

A drop leaf table built for Stephen Esh and Sallie Fisher around the time of their marriage. Attributed to Benjamin Beiler. Collection of Kathryn and Daniel McCauley. 46" x 25¼" x 62", extended.

A microcosm filled with candy-toting grandmothers, gossiping aunts and uncles, fun-loving cousins, and watchful parents, the Amish community of Henry Lapp's and Barbara Ebersol's time was neither backward nor boring. A place where joy followed hardship and clouds followed the sun, women felt fulfilled and anxious, men knew successes and failures, and children longed to follow in their footsteps.

Interspersed throughout the daily lives of Amish families were triumphs—a teenager heeded a parent's warning or a corn harvest brought a bountiful yield—and disappointments—a child disliked school or it rained on the hay. A culture which valued community togetherness far above individual expression and understanding, it was also indeed a society with rigid boundaries, iron discipline, and its resulting share of pain. Amish people criticized the church, battled the world, and touched the pulse of life like persons everywhere.

Probably because the Amish revered the land so highly, the cycle of life and the movement of the seasons generated their celebrations. Ice skating parties enlivened cold winter months. Warm stoves and good conversation brought comfort on long evenings. In the early months of spring, gardens were planted, fields plowed, and houses cleaned as the weather moderated. Summers burst with strawberries, haymaking, watermelons, fresh sweet corn, and hard work. Autumns heralded harvest and weddings and Thanksgiving, and when winter returned, it brought with it the delights and joys of warm, family-filled Christmas revelry.

The Henry Lapp paintings shown on pages 81 and 82 demonstrate the artist's vivid imagination. All are in the collection of The People's Place.

(above) 6½" x 3⅝". (right) 4⅜" x 7⅛".

The Role of Imagination in Amish Life

Much like growing up in any other 19th century cultural enclave—Welsh in the hills just east of Henry's and Barbara's homes, Catholic in the southwest section of Lancaster City, Jewish in Brooklyn, Italian in Queens, or Irish in north Philadelphia—growing up Amish meant a unique set of understandings and experiences.

Among the Amish, which young man took which young woman home from a Sunday evening hymn singing became an important point of discussion. The teenager with the fastest horse or the most unusual new dress fabric was the envy of his or her peers. The neighborhood woman who managed to finish housecleaning first each spring set the pace for everyone else to finish their own homes. And the men participated in an ongoing friendly rivalry to be the first to start plowing in the spring, to get the corn and

tobacco planted, and to begin threshing the wheat.

Life among the Amish was measured in country terms. The weather controlled activities, and people planned their days around the hard work and satisfying toil of farm life. However, Amish people also found time to relax and daydream—in moderation, of course! Many had learned the truth of the adage, "All work and no play makes Jack a dull boy." Children were encouraged to play together and to grow together. Young people enjoyed each other's company. And adults gathered at church, at neighborhood get-togethers, and at family reunions to keep up on the latest community news.

Michael and Rebecca Lapp seem to have fostered

their children's imaginations. Several paintings which depict characters from *Aesop's Fables* survive, suggesting the Lapp children were acquainted with

2¼" x 3⅛".

3⅝" x 3".

These Lapp paintings seem to have been inspired by two of Aesop's Fables: "The Cock and the Pearl" (left, 5¼" x 6½") and "The Frogs Desiring a King" (right, 5⅜" x 3¾"). Collection of The People's Place.

these tales.[5] Like many Amish women of her time, mother Rebecca enjoyed quilting and needlework. Several pieces which she created have survived. It is interesting to note that the design of a "Twin Parrots" needlework piece done by Rebecca Lapp in 1867 appears in several paintings done by the Lapp children in the 1870s.[6] It seems likely that Rebecca Lapp encouraged her children, perhaps even suggesting subjects for their paintings.

The children of Christian and Elizabeth Ebersol probably were also curious about the world. The Ebersol family may have read a weekly newspaper, as well as other farming periodicals published during the late 19th century. Later generations of Ebersols were remembered for their love of the daily newspaper. In a November 12, 1900 letter to his cousin, Barbara Ebersol's nephew, John Speicher, demonstrated his own knowledge of local affairs by writing part of his letter in the language of a newspaper. The title of his paper was "The Dum News." It was published "every once and awhile" and its terms were "$1.00 a year in advance."[7] One of Barbara's nieces, Fannie Lapp Stoltzfus, loved to read the daily "funnies," teaching her children and grandchildren to do the same.[8]

While families varied somewhat in their

approaches to the world, among the Amish most individual choices and decisions came under the careful scrutiny of the community. From early childhood, a youngster's desires and wishes were controlled by his or her parents. The expectations of the church were also always present, and when young people officially joined the community of faith, it was assumed they would submit their imaginations

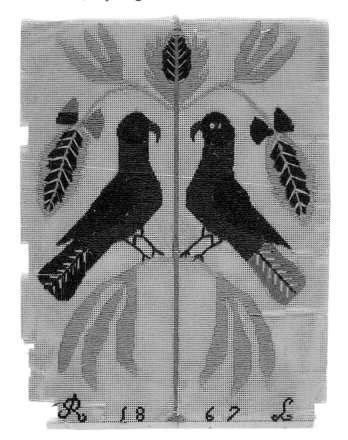

(left) Henny and Lizzie Lapp's mother Rebecca crafted this "Twin Parrots" needlework (7⅝" x 10¼") in 1867. Collection of Kathryn and Daniel McCauley. During the 1870s when the Lapp children were painting prolifically, they did several pieces which resembled her needlework quite closely (right, 8" x 9⅞"). Collection of Bob Hamilton.

and dreams to the church. Furthermore, church membership was usually followed shortly by marriage, children, and the sunrise-to-sunset work of maintaining a farm. Imagination and creativity, while certainly still present, almost always yielded to the wishes of Amish society. A slightly more lenient attitude and standard applied, however, to those who never married or to those who experienced mental or physical challenges. Both Barbara Ebersol and Henry Lapp may have been granted such latitude.

Amish Views about Single People

While marriage was a highly desired state and parents applied considerable pressure to "find someone," 19th century Amish young people were free to choose their own mates. Marriages were not arranged. Rather, young people met each other at Sunday evening gatherings called "singens," at weekday events such as threshings or haymakings, and at the every other week Sunday morning church services.

In October of 1898, Isaac Zook and his wife of nearly a year began planning a "singen" at their home near Eby's Post Office. They received an animated letter from two friends, Barbara Zook and Annie Beiler, filled with references to their high excitement at the news and their intentions to come and have a very good time. Annie Beiler wrote, "we want ice cream and watermelons and cantylopes and cakes and mush for breakfast," indicating the event probably was evolving into more than just a hymn singing.[9] Throughout the letter Barbara and Annie made repeated references to a Nancy Blank and her

desire that both the Upper Pequea and the Gap "gangs" should be invited to the "singen."

If the Isaac and Sarah Zook "singen" went as planned, one of the Sundays in October of 1898 was probably a time of rich celebration for that group of 19th century Amish young people. Prior to marriage, they attended such get-togethers as part of their weekly ritual. It was assumed that young people would break some rules and deviate somewhat from the normal expectations of Amish church life. After marriage, however, young people were required to begin "settling down." Many older Amish probably frowned on Isaac and Sarah Zook's decision to open their home to an all-night hoedown disguised as a "singen." The Zooks were expected to begin breaking away from their old habits and to settle into the more sedate lives of Amish married people.

Those who did not marry, however, enjoyed a level of freedom not afforded to married people. Although Betsy Speicher was only 23 years old in 1902, she wrote, "I joined the old maid society here sometime ago that is very fine now I can do as I please."[10] Her obvious concern with being single, yet the reference to doing as she pleased, reflected the mixture of emotions created in Amish life by the experience of being single. While the tightly-knit community offered certain freedoms to those who did not marry, it also offered them a strange blend of envy and pity. Although this may have been difficult for some single people to accept, the gift of greater freedom seemed to allow most to live well-adjusted, full lives. In fact, a number of the most creative and ingenious Amish have been single. Neither Henry Lapp nor Barbara

Ebersol ever married. Henry's sister Lizzie, also an artist and craftsperson, never married. Three of Barbara's sisters and one of her brothers—none of whom were known to have been artists, but all of whom were colorful people—also remained single throughout their lives.

The single Ebersol women, along with their widowed sister, Lizzie, and two widowed sisters-in-law, Mattie and Esther, created a strong, matriarchal structure in their extended family. Esther Ebersol and Lizzie Speicher with their young sons ran large family farms after their respective husbands died in 1887 and 1890. Mattie Ebersol held her small family of two sons and one daughter together after

the sad and unexpected death of her husband John. The single Ebersol sisters with their brother Jacob meticulously maintained their parents' Mill Creek farm for almost forty years after the death of Christian Ebersol Jr. They made decisions. They had opinions which they expressed freely. And they had little patience with those who did not solve their own problems. The no-nonsense determination, strength of character, and certain resolve of these 19th century Ebersol women found expression among future generations of Ebersol women as well.

Mattie Ebersol's daughter, Fannie, remained single until she was forty years old. Three months after her

On December 3, 1903, Barbara Ebersol's nephew, John Speicher, married Katie Petersheim. Henry Lapp attended the young couple's wedding and gave them this pie carrier as a gift. Collection of Muddy Creek Farm Library. 41½" x 7¾".

fortieth birthday, she married Jacob Stoltzfus. They bought a large farm along the busy Old Road and established a prosperous home. While Jakey farmed the land, Fannie managed a chicken and egg business, occasionally employing young neighborhood boys to gather her eggs.

One day an Amish threshing crew enjoyed a bountiful meal after harvesting Jakey and Fannie's wheat. A crew member slyly asked the independent and outspoken Fannie who was in charge in their home by inquiring in Pennsylvania Dutch, "Who wears the pants anyway?" Without missing a beat, she announced, "We both wear pants."[11]

One of the Ebersol great-nieces, Sarah L. Stoltzfus, who never married, spent her entire adult life from about 1940 to 1985 working as a housekeeper for several well-to-do families in the city of Lancaster. Each weekday morning she briskly walked the mile from her rural home to the local bus stop, rode to the center city, did her daily work, and made the return trip before sundown. She knew and loved the ambiance of downtown Lancaster and could not have imagined her life without her daily excursions out of the Amish world. Each evening when she returned, however, she slipped easily back into her role as a faithful member of the Amish church who cared deeply for her family and who worked hard to keep them happy while she provided a comfortable life for herself.[12] As a single person, she could hold a job away from the family farm, and, consequently, enjoy a certain exposure to the world which many of her married peers did not experience.

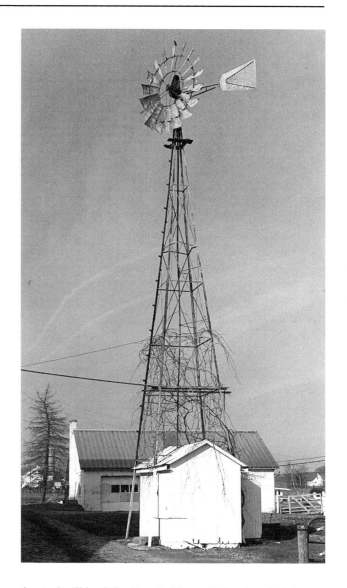

A windmill built by Fannie Ebersol's husband, Jakey.

87

Amish Views about Disabled People

Living in a world where nearly a century of intermarriage had created many genetic problems, 19th century Amish were not strangers to mental and physical handicaps. However, parents hoped and prayed for healthy children. The birth of a handicapped child carried the same burden of pain in an Amish home as it did in any other home. Mothers occasionally denied symptoms which indicated a child might be deaf or slow of mind. When confronted with obvious problems such as dwarfism or Down's syndrome, they too wept.

A certain matter-of-factness, though, permeated the way Amish society viewed hardship and suffering. Babies were not always perfect. Children died. Death and birth were integral parts of the same whole, and Amish families were well acquainted with both. From early childhood most Amish children knew at least one person and sometimes many others who experienced mental or physical challenges of various levels. They were taught to accept and include such children. They, in fact, were often expected to help provide care for brothers or sisters or cousins who could not keep up with the normal pace of games and camaraderie. As a rule, these children were much loved and fiercely protected. Sometimes they also received special and distinctly un-Amish opportunities.

Fannie Ebersol's husband, Jakey Stoltzfus, was hearing impaired, and he attended a special school for the deaf in Philadelphia during the last years of the 19th century. With his brother, Yonie, who was also deaf, Jakey rode the train from Bird-in-Hand to Philadelphia, staying at the school for a week at a time. Jakey and Yonie consequently never learned to speak Pennsylvania Dutch, but they lip-read English and used sign language. During his years at the school, Jakey became quite proficient with a sewing machine. He made his own clothing and, in his later years, sewed quilt tops.[13]

Perhaps Jakey's and Yonie's lives and experiences were influenced by their neighbor and step-uncle, Henry Lapp. Henry's own battle with deafness may have inspired him to suggest special education for the two young sons of his friends, Amos and Katie Stoltzfus. In fact, Henry Lapp's frequent trips to the city may have made the idea of sending Jakey and Yonie to Philadelphia less foreboding to Amos and Katie.

Another example of 19th century Amish views and understandings regarding mental and physical challenges may be found in the life of Christian K. Lapp. Born on February 20, 1889, Christian, one of Barbara Ebersol's nephews and the youngest son of Christ and Mary Ebersol Lapp, never achieved the mental acuity of his sisters, Sarah and Fannie. While the exact nature of his problem was never diagnosed, it was well known in the Amish community that he was "slow." He did, however, attend school and was able to read and write. In a letter to married sister Sarah, Fannie wrote, "I and Christian are going to school this afternoon."[14] While Christian's slow and measured approach to life may have been a disappointment to his parents, his sister Fannie became his protector, standing by him throughout his life. She and her husband, Amos U. Stoltzfus, bought her father's farm and raised their family on

The gravestone of Christian K. Lapp at the Amish cemetery near Gordonville, Pennsylvania.

the one side of the large American manor house on Irishtown Road. "Christly," as he was affectionately called, moved with his retired parents to the other end of the house.

When Uncle Jacob Ebersol died in September of 1934, he remembered Christly in his will. Also single, Jake Ebersol had become very wealthy dealing in gold bonds and stocks, as well as owning real estate and farming, and he left an estate valued around $100,000. He directed that his assets be divided equally among his many nieces and nephews, while making a special provision: "I give and bequeath . . . to the Lancaster County National Bank of Lancaster, Pennsylvania, as Trustee for my nephew, Christian K. Lapp, the sum of One Thousand Dollars ($1,000.00)." Jacob also

directed that the share belonging to Christly, along with the extra $1,000, be held by the bank with interest paid to him each April 1 for the rest of his natural life.[15] Unfortunately, Christly never made use of the careful provisions of his Uncle Jacob.

Only a week or two after Jake himself died, word came to the Amos and Fannie Stoltzfus home that the forty-five-year-old Christly had been badly hurt when he fell from a hay wagon while helping to load hay on a neighboring farm. Fannie sent husband Amos and their six-year-old son, Jonathan, to bring Christly home. While Jonathan sat in the back seat of the buggy holding Christly's glasses, Amos held the injured man and drove the half mile across the railroad tracks to his own farm. Christly died at home on October 26, 1934. Fannie carried her deep grief over his loss for the rest of her life, often telling stories about her beloved brother, Christly.[16]

Such an atmosphere of deep love and care pervaded 19th century Amish thought about people such as Henry Lapp and Barbara Ebersol. Encouraged to pursue creative activities, these physically and mentally challenged persons were often undergirded with special provisions. Indeed, as has been true throughout the centuries of Amish life, most 19th century Amish homes exuded a profound warmth of character and gentleness of spirit, providing places where children and young people were nurtured and where life in all its fragility was revered.

5.

The Final Months of Henry's and Barbara's Lives

The Death of Henry Lapp

Henry Lapp either painted or varnished most of his furniture. While his shop had lots of windows, he probably did most of his finishing work during the winter months when the building would have been tightly closed. Family members who remembered his shop reported that, at some places, the walls were literally covered with layers of paint and varnish. It appeared he cleaned his brushes by lathering them against the walls.[1]

Henry's formal death certificate listed "dropsy" as the cause of his death. Researchers have come to believe he died of lead poisoning. Given the conditions under which he worked and the high content of lead in the paints, it is certainly possible that his work

(right) An Amish farm in winter.

contributed to his crippling sickness at age forty-one.

One Lapp relative remembers stories about the last weeks of Henry's life. So weakened by his illness that he could not work, he would sit for hours by the front door of his home, watching the wagons, buggies, and the daily Intercourse stage pass by on the Old Road.[2] Following a four-month illness, Lapp died at home on July 5, 1904. Two days later on July 7, he was buried at the Amish cemetery near Gordonville, Pennsylvania.

Henry Lapp's will bequeathed "his property situated along the old road, his household furniture and his personal property" to his brother and sisters. After giving the shutter bolt patent to his step-cousin, Noah Beiler, he also directed that Beiler should "be well paid for his work and trouble." That vague phrase probably created some problems for Jacob Lapp, his neighbor and executor of his will.

Henry Lapp further asked that "all surplus money or money not needed to pay aforesaid Noah Beiler

(above) The original front door of the house that Henry Lapp built. According to oral history, he sat by this door during the last months of his life, watching the world pass by on the busy highway within a few feet of his house. Collection of The People's Place. 35¾" x 77⅝".

(right) Henry Lapp and his beloved sister Lizzie were buried side by side at the Gordonville Cemetery within several miles of their adult home.

Barbara Ebersol's gravestone at the Myer's cemetery near Leola, Pennsylvania.

or other necessary expenses should be given to Amos Lapp, Bishop of the Amish Church, said money to be used among the Poor wherever necessary." An inventory of assets related to Henry's business, taken on July 26, 1904, indicated he had $1,048.52 to his name. Certainly not wealthy in the tradition of his own father or the Ebersol family,

Henry Lapp left a profound statement of who he was by sharing what he had with those who needed it most. His creative gifts and gentle spirit were deeply missed in the Amish community when he died in the prime of his life.[3]

The Death of Barbara Ebersol

Nearly eighteen years later on Tuesday, April 4, 1922, Barbara Ebersol died at age seventy-five. A letter to *The Budget* reported she suffered from a complication of diseases. The same letter remembered "little Barbara Ebersol the dwarf, whom so many or most of our western visitors who came to Lancaster Co. went to see." Especially in her later years, Barbara received many visitors and probably spent much less of her time traveling from farm to farm. Rather, she stayed with her single sisters, Nancy and Katie, and her brother, Jacob, at their home on the Mill Creek Valley Ebersol farm. *The Budget* correspondent also said, "She will be greatly missed by her sisters and brother, in the neighborhood, and by her many friends."[4]

In her will Barbara directed that her only surviving brother, Jacob; her surviving sisters, Anna (Nancy), Catharine (Katie), Mary, Elizabeth, and Sarah; and her sisters-in-law, Mattie and Esther, get together and, as nearly as possible, divide all her household goods and furniture into equal shares. She further mentioned the term "equal shares" four more times, demonstrating her keen desire that everyone be treated fairly.[5] She was buried with other family members at Myers cemetery near Leola, Pennsylvania.

6.

Collectors Discover Henry Lapp and Barbara Ebersol

Henry Lapp Is Discovered

In the Lancaster County Amish community, Henry Lapp never was forgotten. Nieces and nephews carefully preserved paintings which he had done for them throughout their lifetimes, passing them on to their own children. Lapp flour chests, wall cupboards, wash benches, and desks adorned Amish homes, often refinished or repainted several times to make them look new. Stories of the energetic little man, who had difficulty hearing, but who ran a successful hardware, paint, and furniture business, floated from field to field and farmhouse to farmhouse. Memories, however, began to fade as the years passed.

While Henry Lapp's assistant, Noah F. Zook, operated a furniture shop on Lapp's property for several years after Henry's death, the business went into steady decline. By the 1950s, Lapp's shop had gathered layers of dust and was falling into disrepair, though it still stood next to the house he had built along the busy Old Road. In 1958, the once bustling shop was completely dismantled and moved to a nearby farm where it was rebuilt as a storage shed.[1]

In the mid-1950s, a half century after Henry Lapp's premature death, a Lapp relative sold a large bureau to a local antique dealer. In one of the bureau's seven drawers, the dealer discovered Henry Lapp's furniture catalog.[2] A noted collector of antiques, Titus Geesey, acquired the catalog on one of his weekly treks through the southeastern Pennsylvania countryside. When Geesey gave it to the Philadelphia Museum of Art in 1958, the preservation of Lapp's handbook was assured, eventually coming into the hands of Beatrice B. Garvan, a supporter and chronicler of Pennsylvania German folk arts and

crafts. The Associate Curator of American Art, Garvan spearheaded the Museum's project to identify Henry Lapp's work and reproduce the catalog. In 1975, seventy-one years after Lapp's death, the Philadelphia Museum of Art in association with Tinicum Press issued a reprint of Henry Lapp's furniture catalog, complete with

descriptions, written by Beatrice Garvan, of each of the plates.[3]

Four years later, the May 1979 issue of *Antique Collecting* splashed a reproduction of the delicately balanced Lapp double distelfink watercolor onto its cover with the lead story, "Henry & Elizabeth Lapp, Amish Folk Artists." The writer, Margaret A. Witmer,

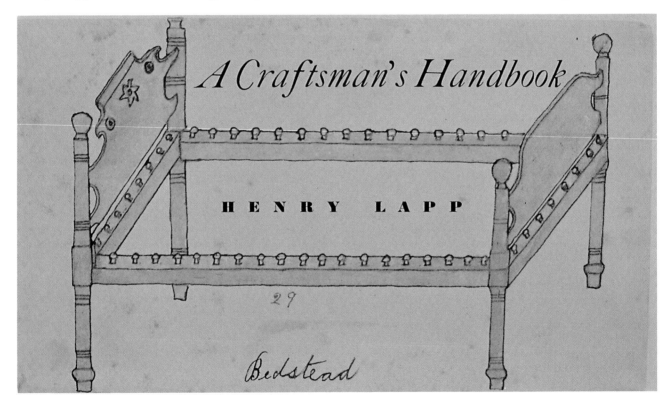

The first reprint of the Henry Lapp furniture catalog. Produced by The Philadelphia Museum of Art and Tinicum Press in 1975. 4¾" x 8¼".

told the story of a group of Lapp paintings held by an Ephrata, Pennsylvania collector, David Musselman. Musselman had purchased the 1872-1879 Elizabeth Lapp scrapbook collection shortly after her death in 1932 at the height of the Depression. The sixty-nine drawings were going to be auctioned at the annual Memorial Day sale at the Historical Society of the Cocalico Valley in Ephrata, Pennsylvania. The story stirred a groundswell of interest among collectors of folk art and fostered a growing fascination with work done by Amish artists and artisans.[4]

On May 28, 1979, historians, collectors, and interested bystanders gathered in full force for the Cocalico Valley auction. The paintings, which were sold individually, brought a total of $31,000. Seventeen pieces went to The People's Place, an educational center interpreting Amish and Mennonite life, located in the village of Intercourse, Pennsylvania. The directors of The People's Place, Merle and Phyllis Good, soon began making plans to open a permanent Henry Lapp exhibit at their heritage center within three miles of both Lapp's birthplace and his adult home.[5]

Working with Lapp relatives in the local community, the Goods spent the next year putting together bits and pieces of Henry Lapp's story. Many Amish had nearly forgotten the gentle and talented man, and those who did remember spoke of his furniture making. Few people, other than his surviving nieces and nephews and some neighbors and friends, knew anything about his penchant for painting. In fact, it seemed not to occur to them that Henry Lapp was an artist.

The Goods came to believe that as an adult Lapp may have done hundreds of paintings on little pieces of paper, always freely giving them to whomever happened to be watching him paint. Many were discarded through the years. Others started to appear at local estate auctions, sometimes only being identified as a Lapp piece the evening before the sale. By June of 1980, The People's Place had increased its holdings to twenty-seven pieces, including everything from the double distelfink to fable characters to various animals, fruits, and vegetables.

Then on a July evening in 1980, the center unveiled its 27-piece permanent Lapp exhibit, with 25 additional Lapp works on loan from six other individuals and organizations. In a celebration of the spirit and intrigue of Henry Lapp, people as diverse as a local Amish Lapp relative, the president of the Lancaster Summer Arts Festival, and a well-known Philadelphia-area artist gathered to inaugurate the one-of-a-kind collection of Amish folk art. The story hit the wires.

On July 4, 1980 *The New York Times* carried photos of the exhibit, along with an extensive account entitled, "Watercolors by Amishman Finally Recognized as Art." Both local Lancaster papers covered the story; it appeared in *The Denver Post* and in remote papers such as the Winfield, Kansas *Daily Courier*.

In October of 1980, the respected antique collectors' paper, *New York-Pennsylvania Collector* began its coverage with the comment, "The gentle watercolors of Henry Lapp are in the news again."

Henry Lapp had been discovered.

Through the 1980s, interest picked up. Amish people marveled at the unexpected fame of one of their own. A correspondent to the weekly Amish newspaper, *Die Botschaft*, wrote, "There is a demand at present for furniture and pictures made

The charming Henry Lapp exhibit in Amish World at The People's Place, Intercourse, Pennsylvania.

This Henry Lapp painting (signed "H. L. 1875") is a copy of the 1868 Ulysses Grant-Schuyler Colfax campaign poster. Henry was only 12 or 13 years old and already showed a keen interest in the larger world. Collection of Bob Hamilton. 18½" x 8½".

by Henry Lapp in the 1870s and later, especially if they are dated and signed…When we were children I remember playing with these pictures never thinking they would be valuable."[6] A year later another correspondent to the paper described the discovery of about twenty Lapp watercolors in a family chest, "These were just small, old looking pieces of paper, worn and torn. Who would have thought when they were put in there they'd be worth anything when they came out?"[7]

Historians and collectors both expressed increasing interest in Lapp's work. Some who owned Lapp pieces opted to place them in historical archives. Others sold their watercolor treasures and pieces of furniture to respected collectors. Still others decided to keep the works within the family, once again passing them on to future generations of Lapp relatives.

In 1986, The Old Road Furniture Company, specializing in reproductions of antique Henry Lapp furniture, opened its doors in Intercourse. There in a shop about two miles from Lapp's own 19th century business, his handsome designs and forms once again became available to the general public. Henry Lapp reproductions are built by Amish cabinetmakers scattered throughout Lapp's former neighborhood. Because the 1975 reprint of Henry's furniture catalog had gone out of print, the company requested and received permission from The Philadelphia Museum of Art to issue a second reprint of the original handbook in 1991. And in 1992, a section of the showroom and mail order operation became the Henry Lapp Museum, complete with his original workbench, the front door and several windows from the house he built, and a collection of furniture he had crafted for Lancaster County Amish families at the turn of the century.

Barbara Ebersol Is Discovered

In 19th century Amish homes, few items were more cherished than the German family Bible, the German hymnals, and the German evening prayer book. Grandfathers handed down their Bibles to namesake grandsons. Grandmothers provided newly married couples with a shining new hymnal or an evening prayer book, often carefully marked by a fraktur artist. Parents conscientiously kept such treasures in safe places. Throwing away a worn and tattered Bible or hymnbook was unthinkable. Thus, unlike the Henry Lapp paintings, most Barbara

A
Craftsman's Handbook

HENRY LAPP

An exquisite reproduction of a rare
notebook, illustrated in watercolor
by Amish furnituremaker Henry Lapp
(1862–1904)

The second reprint of the Henry Lapp furniture catalog. Published by Good Books with The Philadelphia Museum of Art in 1991.

Ebersol bookplates probably have survived.

After Barbara died in 1922, an occasional Ebersol bookplate sold for small money at an estate auction, eventually finding its way either to a museum or into the hands of a collector. Most of her work, however, stayed in the family of the book's original recipient, simply because the Amish did not sell their Bibles and hymnals. Rather, they continued to hand them down to their own children and grandchildren.

Nevertheless, within thirty years of Barbara's death, a person whom The Free Library of Philadelphia called "the dean of fraktur collectors" had acquired three signed Barbara Ebersol bookplates. The first dean of Temple University's law school, Henry Stauffer Borneman, spent more than half his life "gathering together those books and manuscripts which were the essence of the life and culture of the Pennsylvania Dutch." When he died in 1955, the Free Library received his collection of more than 600 fraktur specimens, including the Ebersol pieces.[8]

For the next twenty years, Barbara Ebersol remained relatively unknown. Rarely would a collector or dealer find a marked German Bible or hymnal on the auction block. Then in 1976, Frederick S. Weiser and Howell J. Heaney compiled a two-volume illustrated catalog of the fraktur collection held at The Free Library of Philadelphia. In addition to the three Ebersol pieces obtained from the Borneman collection, the library also had acquired two other Ebersol bookplates and an 1869 drawing of a parrot with the name "Sarah Ebersol"

A collection of German Bibles and hymnbooks, among the most treasured possessions in an Amish home.

inscribed beneath it (see page 105). Weiser and Heaney placed the drawing next to the Barbara Ebersol pieces in the catalog, attributing it to an anonymous artist.[9]

A year later in 1977, David Luthy, an Amish collector and historian from Aylmer, Ontario, was researching fraktur bookplates made both for and by the Amish. He wrote to Emma Huyard, an Amish folk artist, requesting any information she could give him about people in her community who practiced the art of marking books. In her return letter she named several people currently making bookplates and continued, "There was a Barbara Ebersol that used

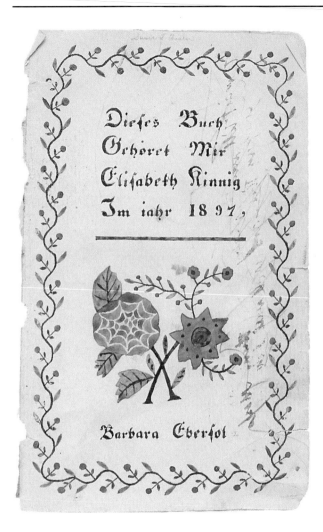

Dieses Buch
Gehöret Mir
Elisabeth Kinnig
Im iahr 18 97,

Barbara Ebersol

The 1897 Elizabeth Kinig bookplate which set David Luthy on a search for Barbara Ebersol's work in the 1970s. Collection of The Heritage Historical Library. 3⅝" x 6".

to mark books many years ago. She was unmarried and a dwarf. She was the daughter of Christ Ebersol. She died in 1922."[10] Immediately intrigued, Luthy set out to find out more about Barbara Ebersol.[11] He decided to search for Barbara's bookplates in the Amish community before prices for her work soared, slowly building what became the extensive Barbara Ebersol Collection found at the Heritage Historical Library in Aylmer, Ontario.[12] Luthy had discovered Barbara Ebersol.

Meanwhile, in the early 1980s, interested buyers such as Daniel and Kathryn McCauley, private collectors from Philadelphia's Main Line, and representatives of San Francisco's Esprit Corporation began making periodic visits to the Lancaster County Amish community searching for quilts and other decorative arts. Collectors began advertising for Amish arts and crafts, often specifically mentioning Henry Lapp and Barbara Ebersol in places like *Die Botschaft* and *The Budget,* two Amish weekly newspapers.

Furthermore, while researching the Henry Lapp story in 1980, Merle and Phyllis Good learned that Henry Lapp and Barbara Ebersol lived on adjoining farms in the Mill Creek Valley during the last years of the 19th century. In an effort to keep some of the work of these two gifted people in the community where they lived and worked and played, The People's Place also slowly assembled a collection of Ebersol bookplates, paintings, and artifacts. Several Ebersol pieces were put on permanent display in the center's Amish World, an exhibit on Amish life and art. And by the mid-1980s, an historian and

The People's Place, Intercourse, Pennsylvania, is home to a large collection of Lapp and Ebersol artwork and artifacts. The directors of this educational center wished to keep some of the work done by these gifted 19th century artists in the community where they had lived.

researcher at The People's Place, Stephen E. Scott, had done extensive work in the local Amish community, searching for answers to his many questions about Henry Lapp and Barbara Ebersol, two unusual and accomplished 19th century Amish people whose talents and expressions seemed incongruous with their otherwise unassuming and quiet Amish lives.

Appendix A

Did Barbara Ebersol Influence Henry Lapp?

When Henry Lapp was in his early teens, his neighbor, Barbara Ebersol, was in her late twenties. The Ebersols and Lapps lived within easy walking distance of each other. Given the proximity of their farms and the support and warmth common in Amish neighborhoods, Barbara Ebersol probably occasionally visited the Michael Lapp home.

As has been noted, Henry and Lizzie Lapp's love of painting could have developed from any of a number of influences—their own mother, their desire to express themselves, or their family activities and interactions. It also seems well within the realm of possibility that Barbara Ebersol may have had some influence on them.

Very few of the Lapp paintings are traditional fraktur pieces. If Henny and Lizzie watched Barbara paint, they were only marginally interested in her bent toward design. However, the double distelfink which

This large bird painting was completed by Henry Lapp in 1876. A matching piece attributed to Barbara Ebersol was once also in the hands of an owner of this Lapp piece. Collection of Bob Hamilton. 7½" x 9⅝".

came from the Lapp scrapbook collection is a classic fraktur piece (see page 14). It has the name Lizzie L. Lapp stamped on the back. Was it painted by Henry Lapp and given to sister Lizzie as a gift? Or was it painted by Lizzie Lapp? While the artist cannot be established with certainty, the measured and careful design of the distelfink, unlike some of the more free-flowing Lapp pieces, suggests the influence of Barbara Ebersol.

Another comparison may be built around an exotic parrot perched on a vine with a tulip motif. This design appears in a number of Barbara's pieces and has been called one of her trademark designs. A similar parrot appears among the Lapp paintings. It is executed much more loosely and freely than any of Barbara's parrots. (see below).

Perhaps, however, the most striking support for the idea that Barbara influenced Henry and his sister,

A Barbara Ebersol parrot (left, 4½" x 5¼") and a Lapp parrot (right, 4" x 5"). Both in collection of The People's Place.

(left) This Barbara Ebersol parrot has been in the collection of The Free Library of Philadelphia for many years. In recent years several parrots of exactly the same design and pattern have also been discovered. Sarah Ebersol was Barbara's sister.. Collection of the Rare Book Department: The Free Library of Philadelphia. 6¾" x 8½".

(right) A parrot also believed to be a Barbara Ebersol painting. It appears she gave these to her friends. Collection of Clark Hess. 6¾" x 8½".

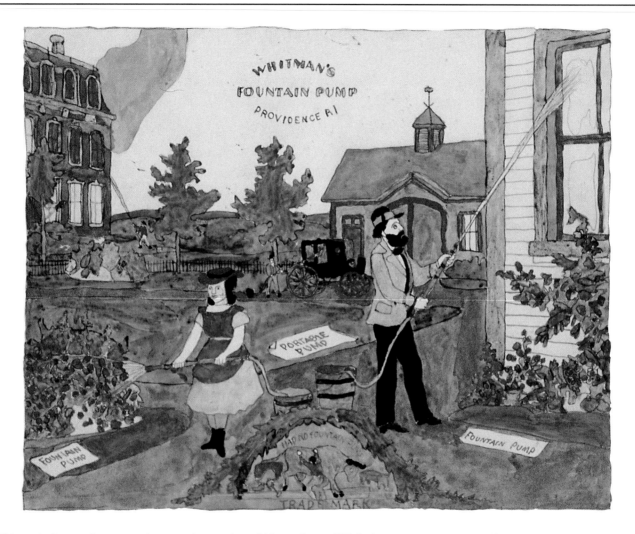

This painting underscores the creative genius of Henry Lapp. While he was copying an advertisement, his well developed human figures are extremely unusual in Amish folk art. Signed on reverse, "Henry Lapp, 1875." Collection of Bob Hamilton. 10½" x 9⅞".

Elizabeth, grows from Margaret Witmer's 1979 article on the Lapps. Witmer explained, "The birds [the double distelfink page 14] pictured on the cover are very similar to one on a drawing by an unknown artist in Lancaster County. This drawing, dated 1869 and lettered 'Sarah Ebersol,' has the same type of buds at the end of the branches and similar decoration on the bird's head and breast as do [the birds on the cover]."[1] Witmer had seen the piece inscribed to Sarah Ebersol among the collection of The Free Library of Philadelphia.

Several years after the publication of Witmer's story, a fraktur piece nearly identical to the piece inscribed to Sarah Ebersol was discovered. Dated and inscribed "Lea Beiler, 1867," the piece and its oral history shed new light on the unknown artist who created the 1869 Sarah Ebersol piece. Because the two pieces are nearly identical, historians attribute both the Sarah Ebersol and the Lea Beiler pieces to Barbara Ebersol.[2] Sarah was Barbara's younger sister and Lea Beiler was probably Barbara's friend. Several other identical pieces (see page 105) have also surfaced since the discovery of the Lea Beiler piece. The 21-year-old Barbara may have painted the parrot for Lea Beiler as a gift. Sister Sarah possibly admired the painting and requested a similar piece for herself. Other friends also evidently became recipients of the treasured pieces.

The fact that Margaret Witmer made a connection between the parrot inscribed to Sarah Ebersol and the Lapp distelfink, without knowing the two artists lived within a half mile of each other at the time each painting was created, underscores the possibility that Barbara Ebersol influenced the two inquisitive Lapp children.

Barbara Ebersol had a precise, Germanic inclination toward perfection. She drew borders around most of her work, clung to balance, and prided herself in meticulous calligraphy. The human figure was very rare in her work. In contrast, Henry and Lizzie Lapp created a whole series of pieces with human figures, seldom used borders or calligraphy, and evidently painted for the sheer love of creating. That they did not merely copy Barbara's work was a credit to their own creative genius.

Appendix B

Discovering Fraktur Artist Barbara Ebersol in 1977

by David Luthy

In 1977 I decided to study and document fraktur bookplates made for and by the Amish. I hoped to obtain enough information to write an article about bookplates for *Family Life* [a monthly periodical on Amish life published by Pathway Publishers]. I knew that some Amish in Lancaster County were still making bookplates, for I had seen a sign hanging above the wide, middle doorway inside Zook's Dry Goods Store in Intercourse, Pennsylvania, advertising fraktur printing by Emma Huyard, daughter of Amos F. Huyard of rural New Holland, Pennsylvania.

On September 29, 1977, I wrote to Emma Huyard, asking her many questions about fraktur bookplates. One of my nine questions was: "Who else in Lancaster County does this type of work?" In her response, Emma mentioned the names of several Amish artists currently doing fraktur printing, and she alwo stated: "There was a Barbara Ebersol that used

to mark books many years ago. She was unmarried and a dwarf. She was the daughter of Christ Ebersol. She died in 1922."

In October 1977, I received a second letter from Emma. This time she enclosed an actual bookplate which Barbara Ebersol had made in 1897. Since the book's flyleaf on which she had made the bookplate was loose from the book, she sent [the flyleaf] for me to see. I was struck by its simplistic beauty and its organization. The reddish-orange colors captivated me, especially one flower which I dubbed her "spiderweb rose." The winding leaf-and-flower border added greatly to its beauty. I held the bookplate and thought, "If this woman made other bookplates, she was an Amish folk artist." I asked to borrow the 1897 bookplate on extended loan and later purchased it for our library. It became the cornerstone of our Barbara Ebersol collection.

Although a few of Barbara Ebersol's bookplates could be found before 1977 among the hundreds of fraktur items in The Free Library of Philadelphia, no private collector was actively assembling a collection of her art until after we had collected quite a few for our library. Collector Daniel McCauley [co-author of *Decorative Arts of the Amish of Lancaster County*] wrote me that he is no longer certain when he bought his first Ebersol bookplate but thinks it was "about 1980 or at the latest 1981."

—David Luthy, May 6, 1993

Endnotes

Chapter One

1. Interview with a Henry Lapp relative who wishes to remain anonymous by Louise Stoltzfus, July 27, 1992.
2. Interview with a Henry Lapp relative who wishes to remain anonymous by Stephen E. Scott and Louise Stoltzfus, December 22, 1988. During this interview, a photocopy of the treasured personal journal notebook was produced. The interviewee stated that a photocopy was made because the holder (another relative) of the original notebook did not wish to show it to anyone.
3. Dudley Clendinen, "Watercolors by Amishman Finally Recognized as Art," *The New York Times*, July 4, 1980.
4. Daniel and Kathryn McCauley, *Decorative Arts of the Amish of Lancaster County* (Intercourse, Pennsylvania: Good Books, 1988), 11.
5. Scott and Stoltzfus interview, December 22, 1988.
6. Margaret A. Witmer, "Henry and Elizabeth Lapp: Amish Folk Artists," *Antique Collecting* (May 1979): 22-27.
7. The People's Place, Intercourse, Pennsylvania holds a large collection of Lapp paintings. The author spent many hours examining the paintings in this collection.

 In 1979 at a Memorial Day auction, the Historical Society of the Cocalico Valley, Ephrata, Pennsylvania, offered for sale the collection of Lapp paintings from the Lizzie Lapp scrapbook. The scrapbook had been purchased by a collector at an auction held by the Lapp family in 1932. Ivan Glick, Lancaster, Pennsylvania, loaned the author a complete slide record of those paintings.
8. Henry Lapp's original furniture catalog sketchbook in the collection of The Philadelphia Museum of Art. It has 46 pages and is $4\frac{1}{2}$" x 8".
9. Scott and Stoltzfus interview, December 22, 1988.
10. Interview with Henry Lapp relative who wishes to remain anonymous by Louise Stoltzfus, May 7, 1994.

Stoltzfus interview, July 27, 1992.
11. Samuel S. Smucker diary entries Tuesday, April 11, 1893 and Thursday, May 23, 1893. Both entries mention frolics to raise a house, stable, and barn for Henry Lapp. The diary is in the collection of Daniel and Kathryn McCauley.
12. Beatrice B. Garvan, introduction and notes, *A Craftsman's Handbook: Henry Lapp* (Intercourse, Pa.: Good Books in cooperation with The Philadelphia Museum of Art, 1991).
13. F.R. Diffenderfer, "The Philadelphia and Lancaster Turnpike," *Papers of Lancaster County Historical Society, Volume VI* (May 2 and June 6, 1902).
14. Henry Lapp's personal journal notebook. Privately held.
15. Interview with Amos Michael Lapp, November 23, 1984 by Stephen E. Scott. Interview with Lapp relative who wishes to remain anonymous by Merle Good, May 1980.
16. One such envelope held at the Muddy Creek Farm Library was shown to the author on September 14, 1994.
17. H.L. Lapp Shutter Bolt. No. 618,958, Patented February 7, 1899. United States Department of Commerce, Patent and Trademark Office, Washington D.C.
18. David Luthy, "Henry Lapp: Amish Folk Artist and Craftsman," *Pennsylvania Mennonite Heritage, Volume XI, Number 4* (October 1988): pp. 2-6. Because the author does not know of an index of articles in *The Budget*, she is indebted to David Luthy for his painstaking research as reported in this article.
19. Hugh F. Gingerich and Rachel W. Kreider, *Amish and Mennonite Genealogies* (Gordonville, Pa: Pequea Publishers, 1986), 244, 258 for the families of Rebecca Lantz and Michael K. Lapp.
20. 1890 Lancaster City and County Directory. Lancaster County Library, Lancaster, Pennsylvania.

21. 1896 Lancaster City and County Directory. Lancaster County Library, Lancaster, Pennsylvania.

22. Joseph T. Butler, *Field Guide to American Antique Furniture* (New York: Facts on File Publications, 1985), 17, 18.

23. Stoltzfus interview, May 7, 1994. The Jacob and Elizabeth Weaver Flaud family lived near and were members of Hellers United Church of Christ, just outside Leola, Pennsylvania. Family oral history says they needed to make very few changes when they decided to join the Amish church in the late 1800s. It is said that all Jake Flaud had to do was to change the buttons on his coats to hooks and eyes.

 Katie Beiler, ed., *Descendants and History of Christian Fisher*, Third Edition (Ronks, Pa.: Eby's Quality Printing, 1988): See numbers 7338 and 7351 for families of Jacob U. Flaud and David Flaud, 261. Hereinafter called *Fisher Family History*.

24. Henry L. Lapp inventory. Archives of the Lancaster County Courthouse. Book V, volume 1, page 447.

25. Original small notebook owned by the Heritage Center of Lancaster County, Penn Square, Lancaster, Pennsylvania. Signed inside front cover: Henry L. Lapp, Groff's Store, Lancaster County, Pennsylvania, Feb. 17, 1890. This inscription has a line drawn through it, and on the opposite page appears the following signature: Henry L. Lapp, Bird-in-Hand, Lanc. Co. Pennsylvania, January 1, 1895. On the inside backcover is the inscription, "I got this book from Henry L. Lapp, Rachel L. Smoker." Rachel was one of the daughters of Henry's sister, Rebecca. The pencil which came with the notebook is still neatly held in its holder inside the front cover.

26. 1897 Montgomery Ward Furniture Catalog. Lancaster County Library, Lancaster, Pennsylvania.

27. Good, Scott, and Stoltzfus interviews, May 1980; November 23, 1984; December 22, 1988; July 27, 1992; and May 7, 1994.

28. Good, Scott, and Stoltzfus interviews, May 1980; December 22, 1988; and July 27, 1992.

29. Henry Lapp's personal journal notebook. Privately held.

30. Butler, 77.

31. In 1986 the Old Road Furniture Company opened for business in the village of Intercourse, Pennsylvania. Contemporary Amish cabinetmakers currently build Henry Lapp reproduction furniture for this thriving showroom and mail order operation.

Chapter Two

1. An 1887 Barbara Ebersol fraktur bookplate now held in the collection of Mennonite Historians of Eastern Pennsylvania, Harleysville, Pennsylvania. This particular book was a gift to a young Amish man, David Blank, from his grandfather, Jacob Blank.

2. Letter from Betsy Speicher to Sarah E. Lapp, January 2, 1892. From a collection of letters written to Sarah Lapp Zook and her husband, Isaac Zook, between 1886 and 1918. Privately held. Hereinafter called the SLZ letters.

3. Stephen E. Scott interviews with Barbara King Ebersol, November 19, 1984; with Susie Esh, November 27, 1984; with Esther Fisher, November 27, 1984; with Leroy Ebersol, November 29, 1984; with Lydia K. Stoltzfus, November 30, 1984; and with John M. Ebersol, December 3, 1984.

4. Fannie Lapp Stoltzfus was the author's grandmother. Her children maintain she learned the art from the colorful Aunt Bevli.

5. This German family Bible currently belongs to one of Fannie Lapp Stoltzfus's sons, Jonathan D. Stoltzfus.

6. Stephen E. Scott interview with Levina Huyard, November 29, 1984.

7. Deed recorded in Book Z, volume 13, page 514, Archives of the Lancaster County Courthouse, Lancaster, Pennyslvania.

8. Letter from Betsy Speicher to Sarah Lapp, October 4, 1897. SLZ letters.

9. Both of these chairs were among the furnishings in the author's grandparents' home, Amos and Fannie Stoltzfus.

10. Stephen E. Scott interview with John M. Ebersol, December 3, 1984.

11. The People's Place, Intercourse, Pennsylvania, purchased the crutches from Moses Blank, one of Barbara's great-nephews, in 1986.

12. Conversation between four daughters of Stephen and Mary Lantz—Lydia, Barbara, Miriam, and Rebecca—and Louise Stoltzfus, January 22, 1993. Conversation between Emma Huyard King and Louise Stoltzfus, February 26, 1993.

13. Stephen E. Scott interview with Enos K. Zook, November 26, 1984.

14. From interviews conducted by Stephen E. Scott with various Ebersol relatives and friends in 1984.

15. Telephone conversation between Daniel McCauley and Louise Stoltzfus, May 19, 1994. Christ Speicher, son of John Speicher, recalled the wheelbarrow story in an interview with Daniel McCauley in November 1988.

16. Letters from Nancy Gingerich to Sarah Lapp, February 28, 1892; December 12, 1892; January 27, 1895; and March 22, 1896. SLZ letters. The relationship between Nancy Gingerich's mother, Magdalena Lebold Gingerich, and Barbara Ebersol was verified by David Luthy in a letter to the author dated May 7, 1993. Magdalena and Barbara were first cousins.

17. Donald A. Shelley, *The Fraktur Writings or Illuminated Manuscripts of the Pennsylvania Germans* (Allentown, Pa: The Pennsylvania German Folklore Society, 1961), 43.

18. Paul Conner and Jill Roberts, comps., introduction by Don Yoder, *Pennsylvania German Fraktur and Printed Broadsides: A Guide to the Collections in the Library of Congress* (Washington: Library of Congress, 1988), 9-13.

19. Frederick S. Weiser and Howell J. Heaney, *The Pennsylvania German Fraktur of The Free Library of Philadelphia, Volume One* (Breinigsville, Pa: The Pennsylvania German Society and The Free Library of Philadelphia, 1976), xvi-xxvii.
 The fraktur collection at the MeetingHouse, a Mennonite heritage center near Harleysville, Pennsylvania, includes numerous pieces by such schoolmasters as Christopher Dock, Christian Strenge,

 and Isaac Ziegler Hunsicker.

20. Michael S. Bird, *Ontario Fraktur: A Pennsylvania-German Folk Tradition in Early Canada* (Toronto: M.F. Feheley Publishers, Ltd., 1977), 12-19.
 Ethel Ewert Abrahams, *Frakturmalen und Schönschreiben*, privately published, 1980, 11, 12.

21. Yoder introduction in Conner and Roberts, 9-13.

22. From a study of pieces owned by The People's Place, Intercourse, Pennsylvania, and by Heritage Historical Library, Aylmer, Ontario.
 1860 Upper Leacock Township Census Record. Lancaster Mennonite Historical Library, Lancaster, Pennsylvania.

23. McCauley and McCauley, 116, 117.

24. McCauley and McCauley, 121.

25. See Beatrice B. Garvan and Charles F. Hummel, *The Pennsylvania Germans: A Celebration of Their Arts 1683-1850* (Philadelphia: Philadelphia Museum of Art, 1982), plate 92, for photograph of an etching which shows Washington crossing the Delaware. Barbara Ebersol may have seen this piece or one similar to it in a school book.

26. David Luthy, "Amish Folk Artist: Barbara Ebersol (1846-1922)," *Pennsylvania Mennonite Heritage, Volume XIV, Number 2* (April 1991): 5.

Chapter Three

1. Joseph F. Beiler, "Our Fatherland in America: The Ebersol Family," *The Diary, Volume 12, Numbers 5 and 6* (May 1980): 142-144; (June 1980): 180-183. Beiler cites *The Bernese Anabaptist* by Ernst Muller as his source.

2. *Fisher Family History*, 385.

3. A handwritten note by Barbara Ebersol which was placed inside a camphor bottle which she bought from her grandparents. Held by the Muddy Creek Farm Library. Shown to the author September 14, 1994.

4. Deed recorded in Book Z, volume 13, page 514. Archives of the Lancaster County Courthouse, Lancaster, Pennsylvania.

5. SLZ letters. This collection includes two German letters written by Mary Ebersol Lapp (Barbara's sister) and one English letter written by Catherine (Katie) Ebersol (also Barbara's sister).

6. Stephen E. Scott interviews with Barbara King Ebersol, November 19, 1984; and Aaron and Fannie Lantz King, November 23, 1984.

7. Franklin Ellis and Samuel Evans, *History of Lancaster County, Pennsylvania, with Biographical Sketches of Many of Its Pioneers and Prominent Men* (Philadelphia: Everts and Peck, 1883), pp. 928, 932-933.

8. 1850, 1860, and 1870 Leacock Township and Upper Leacock Township census records. Lancaster Mennonite Historical Library, Lancaster, Pennsylvania.

9. According to footnote 1 in Luthy, "Henry Lapp: Amish Folk Artist and Craftsman," 2-6, records concerning the date of Henry Lapp's birth are not consistent. Henry Lapp's tombstone indicates August 22. The *Fisher Family History* gives August 18. Barbara Ebersol's personal notebook of death records (in the Heritage Historical Library Collection) shows August 20.

10. Deed recorded in Book Z, volume 13, page 516, Archives of the Lancaster County Courthouse.

11. Deed recorded in Book C, volume 14, page 562, Archives of the Lancaster County Courthouse.

12. Inventory of Christian Ebersol, Book P, volume 1, page 425, Archives of the Lancaster County Courthouse.

13. Will of Christian Ebersol, Book I, volume 2, page 443, October 9, 1890. Archives of the Lancaster County Courthouse.

14. Stephen E. Scott interview with John M. Ebersol, December 3, 1984.

15. Stephen E. Scott interview with Esther Fisher, November 27, 1984.

16. Stephen E. Scott interview with Levina Huyard, November 29, 1984.

17. Mary Ebersol Lapp was the author's great grandmother.

18. Louise Stoltzfus interview with Moses Blank, January 22, 1993.

19. Letter from Betsy Speicher to Sarah Lapp, November 3, 1896. SLZ letters.

20. Stephen E. Scott interview with Enos K. Zook, November 26, 1984.

21. Account record book between C.D. Buckwalter and Michael K. Lapp dated April 1, 1880 through December 31, 1880. Collection of The People's Place, Intercourse, Pennsylvania.

22. Telephone conversation between Daniel McCauley and Louise Stoltzfus, May 19, 1994. The circumstances of Michael Lapp's death were recorded in a notebook compiled by Lydia Beiler between 1878 and 1915. Notebook in the collection of Daniel and Kathryn McCauley.

23. Inventory book L, volume 1, page 235 and Bond book H, volume 2, page 274. Archives of the Lancaster County Courthouse.

24. Accounts and reports book 49, page 63. Archives of the Lancaster County Courthouse.

25. The 1890 Lancaster City and County Directory lists: Rebecca Lapp, widow farmer, Groff's Store and Henry L. Lapp, carpenter, Groff's Store.

26. "Suicide of a Wealthy Farmer," *The New Era—Lancaster*, 23 July 1881.

27. Bond book E, volume 2, page 350 held in the Archives of the Lancaster County Courthouse says John Ebersol died without having made a will at 5 o'clock in the forenoon on July 22, 1881 in Upper Leacock township. An April 21, 1874 deed recorded at Lancaster County Courthouse between Christian and Elizabeth Ebersol and their son, John, refers to them advancing him $5000 as part of his share of their estate. It also mentions "a certain bond of performance duly executed, signed and acknowledged by the said John Ebersole second party hereto unto the said Christian Ebersole and Elizabeth his wife bearing equal date herewith on reference the whole will more fully appear." While that document has disappeared, it seems John agreed to

certain actions in a legal document drawn up between himself and his parents.

28. Jonathan and Daniel were the brothers of Fannie Lapp Stoltzfus, the author's grandmother.

29. Will of David Ebersol, Book G, volume 2, page 414, March 9, 1887. Archives of the Lancaster County Courthouse.

30. *Lancaster Examiner and Herald*, 13 May 1846; 20 May 1846.

31. Frederic Shriver Klein, *Lancaster County Since 1841* (Lancaster, Pa.: The Lancaster County National Bank, 1955), 17-18.

32. Gideon L. Fisher, *Farm Life and Its Changes* (Gordonville, Pa.: Pequea Publishers, 1978), 86-87.

33. Frederic Shriver Klein, 93.

34. The People's Place, Intercourse, Pennsylvania, has in its possession several hand-rolled cigars which were rolled by Barbara Ebersol and saved by nephew Jonas Ebersol's family.

35. *Daily Evening Express*, 12 September 1862, as cited in Frederic Shriver Klein, 41.

36. James O. Lehman, "Duties of the Mennonite Citizen: Controversy in the Lancaster Press Late in the Civil War," *Pennsylvania Mennonite Heritage, Volume VII, Number 3* (October 1984): p. 7.

37. *Daily Evening Express*, 19 June, 29 June, 2 July, and 17 July 1861. *Lancaster Intelligencer*, 25 June 1861. *Lancaster Examiner and Herald*, 17 July, 24 July, 7 August, and 14 August 1861. The author learned of the debate when reading James O. Lehman, "Conflicting Loyalties of the Christian Citizen: Lancaster Mennonites and the Early Civil War Era," *Pennsylvania Mennonite Heritage, Volume VII, Number 1* (April 1984): pp.2-15.

38. Paton Yoder, *Tradition and Transition* (Scottdale, Pa.: Herald Press, 1991), 26-29.

39. *Tradition and Transition*, 32-34.

40. David Beiler, "Memoirs of an Amish Bishop," translated and edited by John Umble. *Mennonite Quarterly Review, Volume 22* (April 1948): 94-115.

41. Paton Yoder, *Tennessee John Stoltzfus: Amish Church-Related Documents and Family Letters* (Lancaster, Pa.: Lancaster Mennonite Historical Society, 1987), 289.

42. David Beiler as translated in *Mennonite Quarterly Review*, 105.

43. Minutes ("Proceedings") of all sixteen *Diener Versammlungen* sessions are available in German from many Amish and Mennonite historical libraries. This reference cites historian Paton Yoder's preliminary English translation of those minutes, graciously loaned by Steven R. Estes, Meadows, Illinois.

44. English translation of minutes of *Diener Versammlungen* held May 1863 in Belleville, Pennsylvania.

45. Louise Stoltzfus telephone conversation with Steven R. Estes, Meadows, Illinois, April 1994. Estes called the controversy about rebaptism, "the first major controversy among the Amish in America."

46. David Beiler as translated in *Mennonite Quarterly Review*, 114.

47. Steven M. Nolt, *A History of the Amish* (Intercourse, Pa.: Good Books, 1992), 24-41.

48. John Ward Willson Loose, *The Heritage of Lancaster* (Woodland Hills, Ca.: Windsor Publications, Inc., 1978), 105, 106.

49. Loose, 96-114.

50. Garvan, *A Craftsman's Handbook*, introduction and notes and plate 43.

51. Letter from Betsy Speicher to Sarah Lapp, May 8, 1891. SLZ letters.

52. Letters from Betsy Speicher to Sarah Lapp, July 5, 1893 and July 11, 1897. SLZ letters.

53. H.M.J. Klein, Editor, *A History of Lancaster County, Pennsylvania*, (New York and Chicago: Lewis Historical Publishing Company, Inc., 1924), 369.

54. H.M.J. Klein, 366-369.

Chapter Four

1. Letter from Katie B. Fisher to Sarah E. Lapp, March 27, 1887. Letter from Emma Kauffman to Sarah E. Lapp, April 30, 1888. SLZ letters.

2. Letter from Katie B. Fisher to Sarah E. Lapp, March 30, 1890. SLZ letters.
3. *The Fisher Family History*, 111.
4. Letter from Sallie Fisher to Sarah E. Lapp, December 4, 1892. SLZ letters.
5. From a study of the Henry Lapp paintings in The People's Place Collection. Paintings which appear to be illustrations of the fables, "The Frogs Desiring a King" and "The Cock and the Pearl" are part of this collection.
6. McCauley and McCauley, 37, 124.
7. Letter from John Speicher to Sarah Lapp Zook, November 12, 1900. SLZ letters.
8. Fannie Lapp Stoltzfus was the author's grandmother.
9. Letter from Barbara F. Zook and Annie K. Beiler to Isaac and Sarah Zook, October 16, 1898. SLZ letters.
10. Letter from Betsy Speicher to Sarah Lapp Zook, February 2, 1902. SLZ letters.
11. Conversation between Jonathan D. Stoltzfus, who was present at the threshing, and Louise Stoltzfus, December 1990.
12. Sarah L. Stoltzfus was the daughter of Amos U. and Fannie Lapp Stoltzfus.
13. Stephen Scott, *Amish Houses and Barns* (Intercourse, Pennsylvania: Good Books, 1991), 70.
 Conversation between Jonathan D. Stoltzfus and Louise Stoltzfus, December 1990.
14. Letter from Fannie E. Lapp to Sarah Lapp Zook, March 25, 1898. SLZ letters.
15. Jacob Ebersol will. Book N, volume 3, page 108. Archives of the Lancaster County Courthouse.
16. Conversation between Jonathan D. Stoltzfus and Louise Stoltzfus, December 1990.

Chapter Five
1. Good, Scott, and Stoltzfus interviews, May 1980, November 23, 1984, and December 22, 1988.
2. Stoltzfus interview, July 27, 1992.
3. Henry Lapp will, Book Q, volume 2, page 16, Archives of the Lancaster County Courthouse.
4. *The Budget,* 13 April 1922.
5. Barbara Ebersol will, Book D, volume 3, page 242.

Archives of the Lancaster County Courthouse.

Chapter Six
1. Stoltzfus interview, July 27, 1992.
2. Garvan, *A Craftsman's Handbook*, introduction.
3. Garvan, *A Craftsman's Handbook*.
4. Witmer, 22-27.
 Luthy, "Henry Lapp," *Pennsylvania Mennonite Heritage*, 4, 5.
5. Eugene Kraybill, "Inventive Amishman's Art Displayed," *Intelligencer Journal*, 2 July 1980.
6. *Die Botschaft* (September 19, 1984): 24.
7. *Die Botschaft* (August 21, 1985): 24.
8. Ellen Shaffer, quoted in Weiser and Heaney, Volume One, xxix.
9. Weiser and Heaney, Volume Two, illustrations 683, 684, 686, 687, 688, and 689.
10. Emma Huyard letter to David Luthy, October 1977, quoted in Luthy, "Amish Folk Artist" *Pennsylvania Mennonite Heritage*, 2.
11. Writing included in letter from David Luthy to Louise Stoltzfus, May 6, 1993. See Appendix B for complete transcript of document.
12. Luthy, "Amish Folk Artist" *Pennsylvania Mennonite Heritage*, 3.

Appendix A:
1. Witmer, 26, 27.
2. McCauley and McCauley, 118.

Bibliography

Archival sources, personal interviews, and newspaper sources appear only in the endnotes.

Abrahams, Ethel Ewert. *Frakturmalen und Schönschreiben: The Fraktur Art and Penmanship of the Dutch-German Mennonites While in Europe.* Hillsboro, Ks.: Ethel Ewert Abrahams, 1980.

Beiler, David. "Memoirs of an Amish Bishop." Translated from the 1862 German by John Umble. *The Mennonite Quarterly Review,* Volume 22, April 1948, 94-115.

Beiler, Joseph F. "Our Fatherland in America." *The Diary, Volume 12, Number 5, continued in Volume 12, Number 6.* Gordonville, Pa.: Pequea Publishers, May 1980, June 1980.

Beiler, Katie, ed. *Descendants and History of Christian Fisher (1757-1838), Third Edition.* Gordonville, Pa.: Eby's Quality Printing, 1988.

Bird, Michael S. *Ontario Fraktur: A Pennsylvania-German Folk Tradition in Early Canada.* Toronto: M.F. Feheley Publishers, Ltd., 1977.

Butler, Joseph T. *Field Guide to American Antique Furniture.* New York: Roundtable Press, 1985.

Conner, Paul and Jill Roberts, comps. Introduction by Don Yoder. *Pennsylvania German Fraktur and Printed Broadsides: A Guide to the Collections in the Library of Congress.* Washington: Library of Congress, 1988.

Country Furniture: America's Rich Legacy of Design and Craftsmanship. Alexandria, Va.: Time-Life Books, Inc., *1989.*

Diffenderfer, F.R. "The Philadelphia and Lancaster Turnpike." *Papers of Lancaster County Historical Society,* Volume VI, 2 May 1902, 6 June 1902.

Ellis, Franklin and Samuel Evans. *History of Lancaster County, Pennsylvania, with Biographical Sketches of Many of Its Pioneers and Prominent Men.* Philadelphia: Everts and Peck, 1883.

Fisher, Gideon L. *Farm Life and Its Changes.* Gordonville, Pa.: Pequea Publishers, 1978.

Friesen, Steve. *A Modest Mennonite Home.* Intercourse, Pa.: Good Books, 1990.

Garvan, Beatrice B., introduction and notes. *A Craftsman's Handbook: Henry Lapp.* Intercourse, Pa.: Good Books in cooperation with the Philadelphia Museum of Art, 1991.

Garvan, Beatrice B. *The Pennsylvania German Collection: Handbooks in American Art, No. 2.* Philadelphia: Philadelphia Museum of Art, 1982.

Garvan, Beatrice B. and Charles F. Hummel. *The Pennsylvania Germans: A Celebration of Their Arts, 1683-1850.* Philadelphia: Philadelphia Museum of Art, 1982.

Gingerich, Hugh F. and Rachel W. Kreider. *Amish and Amish Mennonite Genealogies.* Gordonville, Pa.: Pequea Publishers, 1986.

Janzen, Reinhild Kauenhoven and John M. Janzen. *Mennonite Furniture: A Migrant Tradition (1766-1910).* Intercourse, Pa.: Good Books, 1991.

Kauffman, Henry J. *Pennsylvania Dutch American Folk Art.* New York: Dover Publications, Inc., 1964.

Klein, Frederic Shriver. *Lancaster County Since 1841.* Lancaster, Pa.: The Lancaster County National Bank, 1955.

Klein, H.M.J., ed. *A History of Lancaster County, Pennsylvania.* New York and Chicago: Lewis Historical Publishing Company, Inc., 1924.

Lehman, James O. "Conflicting Loyalties of the Christian Citizen: Lancaster Mennonites and the Early Civil War Era." *Pennsylvania Mennonite Heritage,* Volume VII, Number 2, April 1984.

Lehman, James O. "Duties of the Mennonite Citizen: Controversy in the Lancaster Press Late in the Civil War." *Pennsylvania Mennonite Heritage,* Volume VII, Number 3, July 1984.

Lichten, Frances. *Folk Art of Rural Pennsylvania*. New York: Charles Scribner's Sons, 1946.

Loose, John Ward Willson. *The Heritage of Lancaster*. Woodland Hills, Ca.: Windsor Publications, 1978.

Luthy, David. "Amish Folk Artist: Barbara Ebersol (1846-1922) *Pennsylvania Mennonite Heritage,* Volume XIV, Number 2, April 1991.

Luthy, David. "Henry Lapp: Amish Folk Artist and Craftsman." *Pennsylvania Mennonite Heritage,* Volume XI, Number 4, October 1988.

MacMaster, Richard K. *Land, Piety, Peoplehood: The Establishment of Mennonite Communities in America, 1683-1790*. Scottdale, Pa.: Herald Press, 1985.

McCauley, Daniel J. III. "The Paintings of Henry & Elizabeth Lapp." *Folk Art,* Volume 19, Number 3, Fall 1994.

McCauley, Daniel and Kathryn McCauley. *Decorative Arts of the Amish of Lancaster County*. Intercourse, Pa.: Good Books, 1988.

Nolt, Steven M. *A History of the Amish*. Intercourse, Pa.: Good Books, 1992.

Nutting, Wallace. *Furniture Treasury, Volumes 1 and 2*. New York: MacMillan Publishing Co., Inc., 1928.

Nykor, Lynda Musson and Patricia D. Musson. *The Ontario Tradition in York County Mennonite Furniture*. Toronto: James Lorimer & Company, 1977.

Schlabach, Theron F. *Peace, Faith, Nation: Mennonites and Amish in Nineteenth-Century America*. Scottdale, Pa.: Herald Press, 1988.

Scott, Stephen. *Amish Houses and Barns*. Intercourse, Pa.: Good Books, 1992.

Shelley, Donald A. *The Fraktur Writings or Illuminated Manuscripts of the Pennsylvania Germans*. Allentown, Pa.: The Pennsylvania German Folklore Society, 1961.

Sprigg, June and David Larkin. *Shaker Life, Work, and Art*. New York: Stewart, Tabori & Chang, Inc., 1987.

Stoudt, John Joseph. *Early Pennsylvania Arts and Crafts*. New York: A.S. Barnes and Company, Inc., 1964.

Swank, Scott T., Benno M. Forman, Frank H. Sommer, Arlene Palmer Schwind, Frederick S. Weiser, Donald H. Fennimore, Susan Burrows Swan, and Catherine E. Hutchins, eds. *Arts of the Pennsylvania Germans*. New York: W.W. Norton, 1983.

Weiser, Frederick S. and Howell J. Heaney, comps. *The Pennsylvania German Fraktur of The Free Library of Philadelphia: An Illustrated Catalogue, Volumes 1 and 2*. Breinigsville, Pa.: The Pennsylvania German Society, 1976.

Witmer, Margaret A. "Henry and Elizabeth Lapp: Amish Folk Artists," *Antique Collecting*, May 1979, 22-27.

Yoder, Elmer S. *The Beachy Amish Mennonite Fellowship Churches*. Hartville, Oh.: Diakonia Ministries, 1987.

Yoder, Paton. *Tennessee John Stoltzfus: Amish Church-Related Documents and Family Letters*. Lancaster, Pa.: Lancaster Mennonite Historical Society, 1987.

Yoder, Paton. *Tradition and Transition: Amish Mennonites and Old Order Amish, 1800-1900*. Scottdale, Pa.: Herald Press, 1991.

About the Author

Louise Stoltzfus is a native of Lancaster County, Pennsylvania. Barbara Ebersol was her great-great aunt, and stories of Barbara's unusual personality and life drifted through her childhood. Stoltzfus's grandparents owned pieces of Henry Lapp furniture and had several German Bibles and hymnbooks which were marked by Barbara Ebersol.

Stoltzfus is an editor for Good Books. She is co-author of *The Central Market Cookbook* and *The Best of Mennonite Fellowship Meals*; co-author of *Lancaster County Cookbook*; and author of *Favorite Recipes from Quilters*.

Stoltzfus recently finished a project among Lancaster County Amish women and has written the memoir, *Amish Women: Lives and Stories*. She lives in the city of Lancaster, ten miles from her ancestral home.